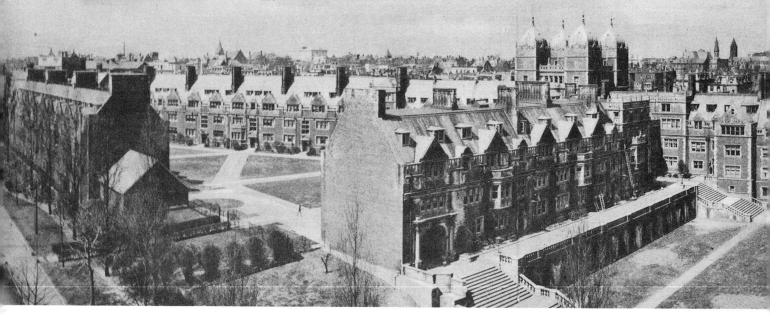

PANORAMA VIEW OF UNIVERSITY OF PENNSYLVANIA.
3—DORMITORIES.

in Picture Postcards

Vestal
Press

The Vestal Press, Ltd.
Vestal, NY 13850

Philadelphia

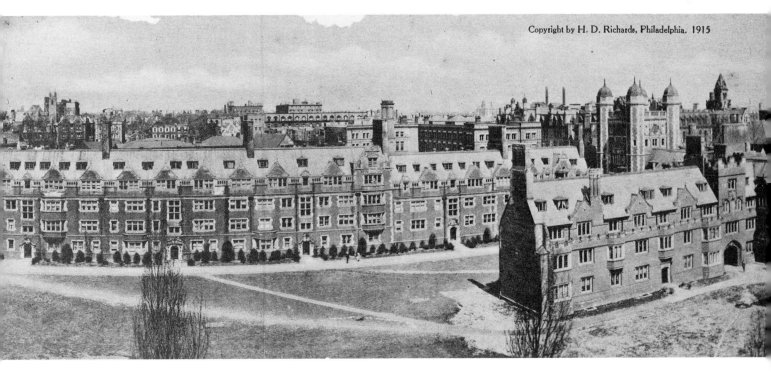

Copyright by H. D. Richards, Philadelphia. 1915

1900–1930

by Philip Jamison, III

Introduction by Thacher Longstreth

Thanks . . .

. . . to Urban Archives Center, Temple University Libraries; Library Company of Philadelphia; Irv Glazer; Jane Jamison; Kate Kelley; Atwater Kent Museum; John McIlhenney, Fairmount Park Historian; The Philadelphia Historical Commission; Robert Skaler; and all people who answer questions that they do not have to.

Notes from the Author

I've grouped these postcards roughly by subject, which seemed as good a way as any. The dates are postmarks, rather than the year the photograph was actually taken. When possible, the copyright date is also included. Dates do not appear on all cards because many of them were never actually mailed.

Please forgive me if your favorite landmark is omitted . . . there are just too many for one book. Some subjects are also just not available—such as the Disston Saw Company; The Curtis Institute; and that local institution, The Mummers Parade. The author would appreciate any additions and corrections, which can be addressed c/o The Vestal Press, Ltd.

Preface

In an effort to streamline his writings about Philadelphia, Nathaniel Burt devised the abbreviations "F. B. F." and "F. & O.," which mean "founded by Franklin" and "first & oldest." When you come right down to it, everything of any importance in this city seems to be either one or the other—or both. If Franklin were alive today, he would surely throw out the baseball at every season opener, lead the Mummer's Parade, write a column for *The Philadelphia Inquirer* (or perhaps, *The Daily News*); and when pressing events arose, his telephone would ring off the hook. All this, and the man was born in *Boston*.

Paradoxes like this are found throughout the streets of Philadelphia. For example, some of the finest housing in the country, built by the rich and famous of yesteryear, lies today in rotting, debris-strewn neighborhoods, its doors and windows boarded up. Compare this with Society Hill, the most exclusive residential area in town; thirty years ago, Al Capone would have been uneasy visiting here. In short, Philadelphia is like any other American city . . . only more so.

It enjoys (and abuses) more important architecture than any other city in the U. S. George Washington slept *everywhere* here. Frankie Avalon was born here as was W. C. Fields. Even the United States was born here. Sound interesting? Well, turn the page and see what people saw eighty years ago. A lot of it can still be seen today.

Table of Contents

Introduction

For 300 years Philadelphia has been, and continues to be, a unique combination of history, charm, and remarkable consistency. Consequently, this beautiful city presents both pictorial connections with the past and a large still-standing collection of original buildings, grounds, streets, and neighborhoods. The pictorial connections are to be seen not only in museums and institutions but also in myriads of private collections, formal and informal, large and small. The still-standing physical evidence of our past is here in abundance, easily accessible and frequently well preserved.

Philip Jamison presents a pictorial collection of Philadelphia's past in an informative and entertaining fashion. *Philadelphia in Picture Postcards, 1900–1930* is a factual representation of our history made up principally of postcards collected by the author. It is organized by chronology and by subject matter so that it can be used as an important addition to Philadelphia's history or as a nostalgic tour through our city's past. It is a delightful stroll down memory lane for those of us in our 70's or beyond who can remember the scenes themselves or hearing parents and grandparents discuss them. But more important, it enables younger generations of Philadelphians to learn about their city simply and enjoyably. It is particularly pleasant to make the comparisons between what is here today and what existed in the same locations decades ago.

In my youth, I worked for *LIFE* magazine, started by Henry Luce and Time, Inc. in 1936. *LIFE*'s mission was "to see life, to see the world" through the medium of pictorial journalism, a relatively new technique that accompanied the communications transition from the printed word to radio to television and the computer. Philip Jamison skillfully uses pictorial journalism in this book to preserve fascinating data for all Philadelphians (and I include here all who live in a radius of 30 miles from City Hall) via an amazing collection of postcards and the information that accompanies them.

I was so entranced with the subject matter that I was deep into the book's contents before I realized the tremendous amount of collection and research that has gone into its preparation. I have seen presentations of this kind in exhibits at the Pennsylvania Historical Society and enjoyed them greatly. *Philadelphia in Picture Postcards, 1900–1930* enables you to take the exhibit home and enjoy it at will, due to the perseverance and creativity of Philip Jamison.

The use of postcards as the principle mode of communications is particularly intriguing. Most of us have used cards on our trips for "staying in touch" in a simple and friendly way. When this happens, the message is usually more important than the photo. Not so here. My father always felt that unless you involved people in your travel photography, buying postcards for yourself, or for sending, gave a much better presentation of the important scenery. Philip Jamison's book certainly fills the bill in this particular.

If you are a Philadelphia lover like me, this book will delight your soul and become a treasure to be taken out and relived on appropriate occasions. If you enjoy history or like to find out why things are as they are, you and your children and their children will make *Philadelphia in Picture Postcards, 1900–1930* a part of your permanent library.

Thacher Longstreth
Philadelphia, PA
September 22, 1990

Street Scenes

A Tour Through Center City

In Philadelphia, "Center City" is the part of town more or less within walking distance of City Hall. By the twentieth century, its skyline had begun to race upward; older buildings like the Academy of Music and even Independence Hall were dwarfed and out of scale. Horse traffic bowed to horseless traffic, and electric trolleys plied every major street.

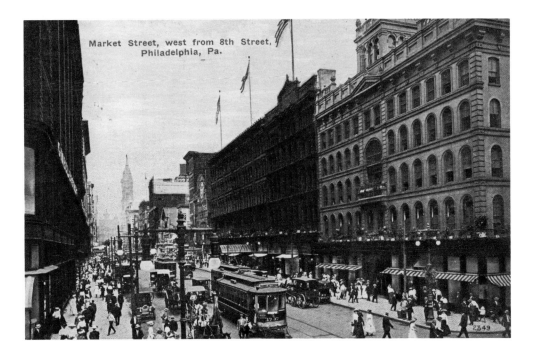

Market Street, west from 8th Street, Philadelphia, Pa.

1914: City Hall is the midpoint of Center City, and Market Street crosses it running east and west. In Colonial days, commerce was focused about the Delaware River (the old City Hall was between 5th and 6th Streets), Eighth Street and beyond were not heavily developed. By the time this card was sent, the real action had shifted westward; and Market Street was lined with sumptuous department stores. On the far right is Strawbridge & Clothier, a store described elsewhere in this book. Almost everything visible here has been removed with the exception of the central portion of Strawbridge's. The Gimbel Brothers store on the left is a parking lot. This card describes the traffic here as being "heavier than at any point in the city." The grey City Hall spire is in the distance.

1

1911: This scene, one block closer west to City Hall, exists no more. On the left is the Federal Building built on the site of the 1792 Presidential Mansion that the City constructed to house Presidents George Washington and John Adams. Unfortunately, both men declined to reside here, so the home was given to the University of Pennsylvania.

In 1884, the Federal Building shown here was built to house a post office and courthouse. It was torn down in 1937 and the present Federal Building opened in 1939. Some historians speculate that Benjamin Franklin flew

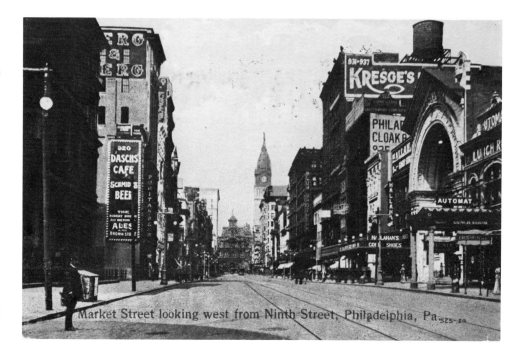

Market Street looking west from Ninth Street, Philadelphia, Pa.

his famous kite in a lightning storm on this spot. The other buildings on the left have been replaced by a block of low-slung modern stores.

The interesting assortment on the right side of Market Street includes an automat and lunch room, and a number of clothing shops. The arched-front building next to the Horn & Hardart Automat is the Victoria Theatre. All were replaced in the late 1970's by The Gallery, a modern (and successful) shopping mall.

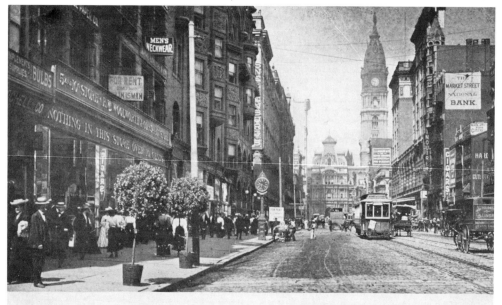

Market St. west from 10th St. Philadelphia, Pa.

We're now close enough to City Hall Tower to read the time. This particular block has changed a great deal recently. All the buildings on the right have been displaced by an addition to the Gallery Mall, and the buildings on the left have been demolished and replaced with modern and much less elaborate architecture. Only one building of this group remains: a narrow storefront covered with sheet metal that houses an electronics shop.

Woolworth's is still on this block but located farther down the street in a newer facility with a different sign. West and across 11th Street, Snellenburg's Department Store can be seen here; it has given way today to a block of double-story, commercial structures. Beyond these buildings is the landmark PSFS building. Built in 1932—about 30 years after this photograph was taken—it was constructed entirely of stainless steel and glass and is known as the country's first modern skyscraper.

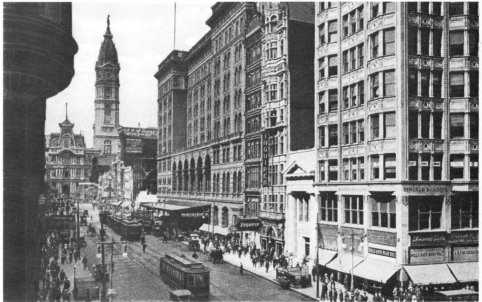

By studying the previous card, the photographer's vantage point can be seen as the building next to Snellenburg's. Today, the right-hand corner in this card would show the Meridian Bank building (including the old "Inquirer" offices, which have moved to North Broad Street). The stone arches next in line down the street belong to the Reading Terminal, which (happily) is still standing. The building with the rounded facade is the Terminal Hotel, a handsome, but now empty, landmark. Beyond the hotel, a squarish building with a sign painted on its brick wall can be seen. This edifice also remains today, its advertising in the same place.

MARKET STREET, WEST FROM 11TH STREET, PHILADELPHIA, PA.

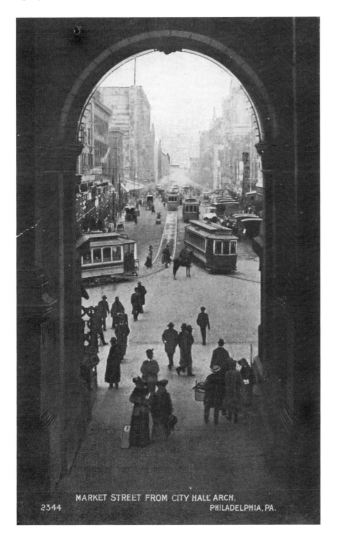

MARKET STREET FROM CITY HALL ARCH, PHILADELPHIA, PA.

2344

1914: This view is still available from the balcony above City Hall's east entrance. The most obvious modern difference would be a line of busses that have replaced this line of trolleys. Below ground level, however, the 1907 Market Street subway still rolls invisibly (if not silently) along.

The wagons to the right are in front of the John Wanamaker store, and the mounted police officer facing them from the center is still a familiar sight in Center City. Note that there is but one automobile on the street . . . a condition that would soon change drastically.

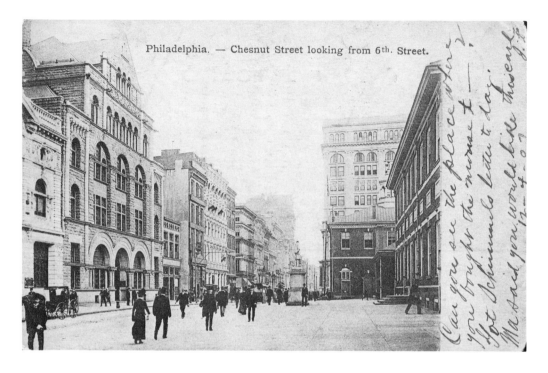

Philadelphia. — Chesnut Street looking from 6th. Street.

1907: This is a vista not existing today because half of the structures on the left were removed after World War II to make way for Independence Mall. These buildings housed The Pennsylvania Company for the Insurance on Lives and Granting Annuities (the structure with the three word-encrusted arches). By counting down five more buildings, the future location of the Lafayette Building (described on page 32) can be seen. Across the street, the north side of Independence Hall can be seen, followed by Old City Hall where the Supreme Court met from 1791 through 1800. The Drexel Building, headquarters of Drexel & Company, bankers, is visible next in line; this structure also still stands.

In the early 1970's, Chestnut Street became a pedestrian mall with access only by bus, although electric trolleys still served much of the city. All the buildings on the right side of this view are gone— about half of them replaced by parking lots and the rest replaced by the 841 Chestnut Street office building.

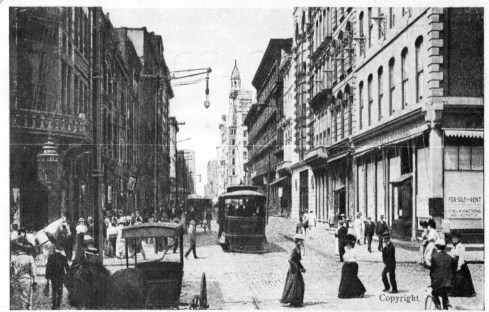

PHILADELPHIA. CHESTNUT STREET LOOKING WEST FROM 8th STREET.

Although the corner building on the left side is gone, the five stores next to it are still standing (though greatly "renovated"). Past these stores, the Continental Hotel (described on p. 79) can be seen; it was torn down in 1925 for the Benjamin Franklin Hotel. The Franklin remains today, although it was converted to apartments and offices in 1980. Also on the left, at 818 Chestnut Street, was Horn & Hardardt's first automat, open from 1902 to 1968.

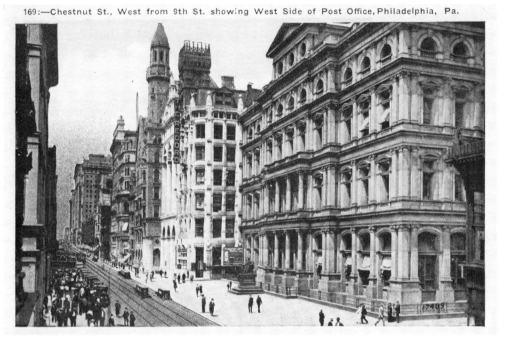

169:—Chestnut St., West from 9th St. showing West Side of Post Office, Philadelphia, Pa.

The three prominent buildings on the right in this view exist no longer: the 1884 U. S. Post Office (also visible in the 9th and Market Street card); the headquarters of "The Philadelphia Record" (the square tower); and next to it, the minaret-like tower of the Penn Mutual Life Building.

Today, beside the new U. S. Post Office, which opened in 1939, is the Federal Reserve Bank, which replaced "The Record" building. This spare, yet impressive, classically-inspired edifice was designed by Paul Philippe Cret in 1932. The bank moved out in 1976, and the building is now occupied by the Pennsylvania Manufacturers' Association.

Next to Penn Mutual's clock tower is The Victory Building, opened in 1873 as a branch office of the New York Mutual Life Insurance Company. Originally four stories tall, it was increased to seven stories in 1890 with the original mansard roof preserved. The structure was designed to be fireproof throughout with iron posts, girders, window frames, and iron window shutters. Today, this lavishly appointed building is empty but still standing.

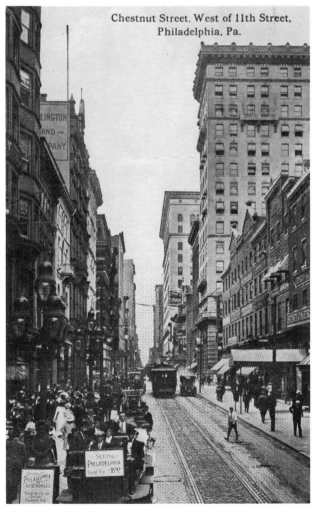

Chestnut Street, West of 11th Street, Philadelphia, Pa.

1917: Chestnut Street runs parallel and one block south of Market Street. If you turn to the theatre section of this book, you may recognize the elaborate street lamp on the left as belonging to B. F. Keith's Theatre. This is where the "Seeing Philadelphia Automobiles" Company departed for their tours of the city and Fairmount Park (seats reserved in advance at $1.00, round trip). (See page 114).

Many of the buildings on the left are still standing, their facades "modernized" with plate glass and sheet metal. The lower block of stores on the right, including the Bellak Piano Company and Dreka Stationers, is now a rather ominous-looking wall of concrete and glass. Beyond it is 1201 Chestnut Street, still standing as the Continental Bank. The next tall structure (with arched windows on top) is Wanamaker's Department store.

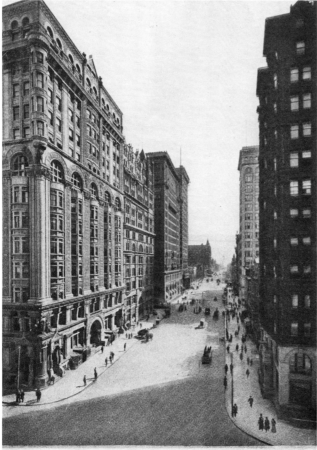

12. *Broad Street looking south from City Hall, Philadelphia*

Copyright 1907 by Taylor Art Co.

1907: This picture, probably taken from a City Hall window, shows some of the area's earliest skyscrapers. On the near left is the earliest of all: the 1891 Betz Building. This was replaced by a new Philadelphia National Bank building, now occupied by Core States National Bank. Second on the left is the Girard Building, designed in 1899 by Addison Hutton. This, too, was demolished for the Core States Bank. The next two squarish buildings are the Real Estate Trust Building and the North American Building, both still standing.

Across the street, the corner building was removed for a 1931 addition to the Girard Trust Company. Looking farther down, it appears that this picture may have been taken before the distinctively domed Girard Bank was completed in 1908 (see page 27). Visible next in line is the 1902 addition to the Land Title Building, still existing as the Provident National Bank.

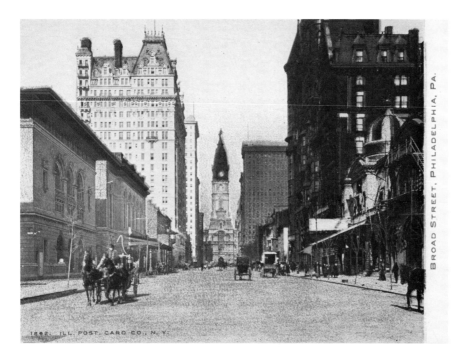

BROAD STREET, PHILADELPHIA, PA.

North to City Hall: Broad Street without automobiles is a strange and tranquil sight—one almost entirely removed from living memory. On the left side of this postcard, the first Horticultural Hall (now the Shubert Theatre) can be seen, followed by the Academy of Music. Next up Broad Street is the Art Club, its curious balcony just visible. Continuing up the street is the Bellevue-Stratford Hotel and the Land Title Building, both still standing.

In the right foreground is the Broad Street Theatre with its newly added fire escapes; the Walton Hotel; and in the distance, the North American Building where the newspaper of the same name was printed. The Hershey Hotel was built on the Walton site in 1983, and cars now park where the Broad Street Theatre was once located.

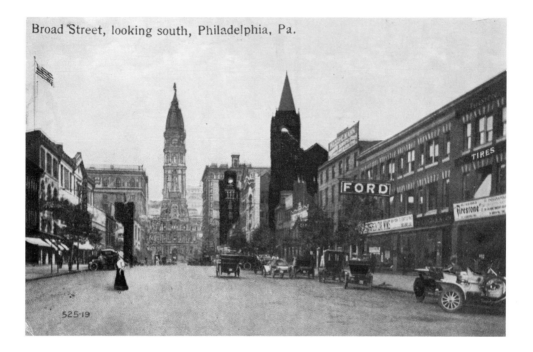

Broad Street, looking south, Philadelphia, Pa.

South to City Hall: North Broad Street was an early center for automobile dealers. The sign over the Ford showroom announces "Ford Stock Car Wins NY-Seattle Race" while Firestone's sign heralds a similar victory at Indianapolis. On the left side of this postcard are the Auto-Car Company (251), Locomobile (245–247), and Oldsmobile. Just visible down the street is the Adelphi Theatre sign.

1917: Walking one block toward City Hall from the previous view and turning around would reveal this scene in 1917. Obviously, not many traffic signals existed at this time; they weren't needed for slow-moving carriages, but the horseless carriage soon hastened their installation. The "Autos" sign on the right is on a building that was a carriage factory in 1909. Farther up, the hexagonal tower belongs to Roman Catholic High School (still standing), the first free parochial school in the U. S. Note that the center of Broad Street was used for parking.

Broad Street from Race Street, Philadelphia, Pa.

Perhaps more can be said about the sites just out of view here. Just behind the camera, for instance, are Strawbridge & Clothier (on left), and Lit Brothers (right). There were almost 20 theatres just up 8th Street between Race and Vine Streets at this time.

Some of the smaller businesses in the city's most important business district are visible in this view.

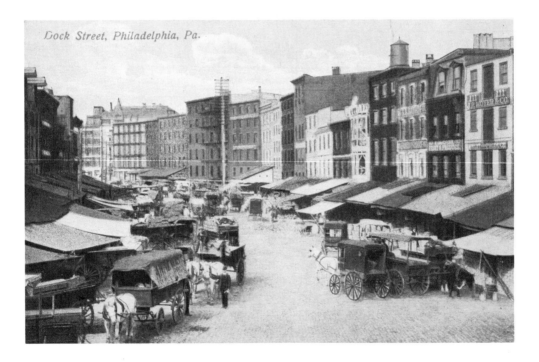

This was the hub of activity in the days when life centered around the Delaware River. Here, produce and other items were delivered to wholesalers. Note the makeshift awnings protecting the goods, and the cobblestone street. These buildings were completely removed in the early 1960's and replaced by the Society Hill Towers apartments and a Sheraton Hotel. The cobblestones remain, however, and the area is linked to Penn's Landing, a popular attraction for both tourists and locals.

This scene looks west on Walnut Street from 18th down to the Church of the Holy Trinity (Episcopal), opened in 1859. Its tower, designed by George W. Hewitt, was completed in 1868. The building with the curved front on the far right still stands, although its neighbors have been removed for offices and parking.

Rittenhouse Square was originally Southwest Square, one of the five green areas created by William Penn; it was renamed for David Rittenhouse. Today, an iron fence and various urns decorate the square and the trolley has been removed; but trees still line the street.

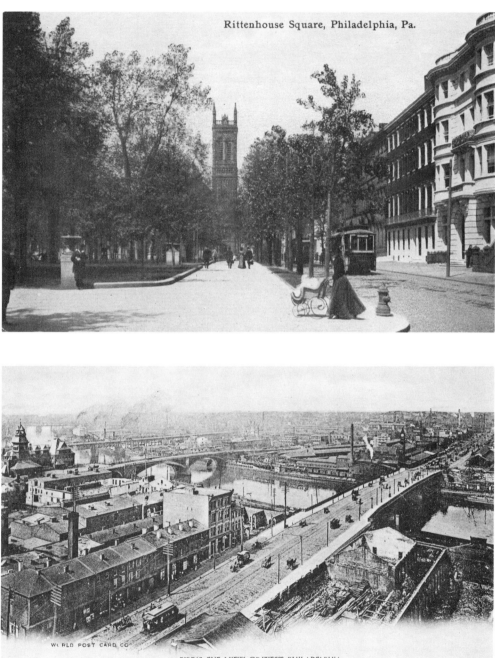

Rittenhouse Square, Philadelphia, Pa.

427. BIRD'S EYE VIEW OF WEST PHILADELPHIA

Since Philadelphia began growing by the Delaware River, its western sections were among the most recently developed. At the time of the U. S. centennial, West Philadelphia was mostly farmland and single-family homes; the only way to Center City was by horse and buggy. In 1907, the electric trains of the EL extended west on Market Street, and the area's population almost tripled by the mid-20th century to 250,000. Factories such as General Electric, ACF Brill, Fels Soap, Breyers Ice Cream, and the Chilton Press offered employment. But jobs followed people to the suburbs after World War II, and West Philadelphia is no longer as prosperous as it once was.

This circa 1900 photograph shows the route west along Market Street and over the Schuylkill River. Farther to the left are the Chestnut Street Bridge and the Walnut Street Bridge, the latter of which stood until 1988. Just across the river on the left (south) side of Market Street, lined with produce carts, is the West Philadelphia Market. To the left of the Market, between Walnut and Spruce Streets, is the Allison Car Works, manufacturers of railroad cars. Today, the Market is the U. S. Post Office; across the street stands 30th Street Station. The fancy building with the tower at the far left is the Baltimore & Ohio Railroad Station, which no longer stands.

69th St. looking North, Philadelphia, Pa.

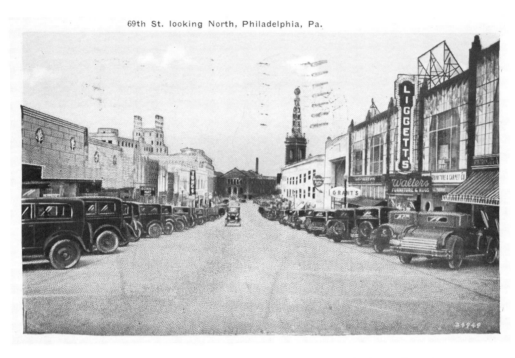

1932: We cheat our 1930 date limit to include this view of the city's western-most shopping district. Virtually all these buildings still stand, although the store facades on both sides of the street have been covered in a unifying stucco and are hardly recognizable.

At the end of the road is 69th Street Terminal, remodelled and in good shape today, although somewhat obscured by a new pedestrian bridge. To the right is the trusswork (taken from another building) of the Tower Theatre, host today of grand musical events in its large hall. The taller building about three-quarters of the way down the left is now the Glendale Bank.

Thousands of suburban shoppers came to patronize businesses in this area before the shopping mall era. Even today, there are still quite a few stores here.

Benjamin Franklin Parkway, 1929: Ideas for a grand Boulevard from Center City to Fairmount Park were discussed from the time of the Centennial Exposition, but not until 1918 did French city planner Jacques Greber put the many proposals together into what became the Benjamin Franklin Parkway. Since the entire area northwest of City Hall was developed in the traditional grid pattern, dozens of factories and warehouses had to be demolished to make space for this wide diagonal thoroughfare.

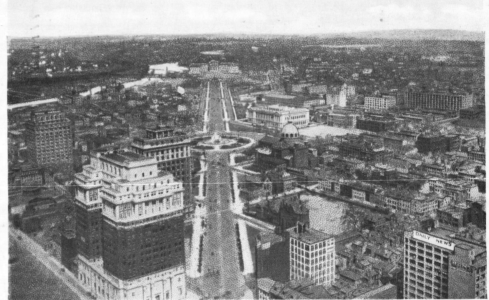

120. PARKWAY FROM CITY HALL, SHOWING MUSEUM, PHILADELPHIA, PA. 121334

This photo was taken from atop City Hall and shows, in the center, Swann Memorial Fountain at Logan Circle and, to its right, the dome of Sts. Peter & Paul Cathedral, and the limestone columns of the Free Library just behind the cathedral. A plot has been cleared to the right of the Library for its architectural twin, the County Court Building. The Franklin Institute, built a year after this card was sent, now stands opposite the Free Library. The Rodin Museum is not visible here, indicating the picture was taken sometime before 1929. At the opposite end of the Parkway is the Pennsylvania (now "Philadelphia") Museum of Art and, behind it, the Schuylkill River and Fairmount Park. The little trees seen here lining the road grew to impressive heights but, alas, succumbing to disease and city life, were dug up and replaced in 1989.

1926: This 300-foot wide roadway opened up the northeastern sections of the city to development—first by industry (see Sears view below) and then by those *employed* by industry. Here we see the relatively verdant Boulevard as it appeared in the mid-twenties, the sooty factories in the distance. This was a section of the Lincoln Highway between Philadelphia and New York opened to traffic in 1911 as Northeast Boulevard. After Theodore Roosevelt's death, it received its present name.

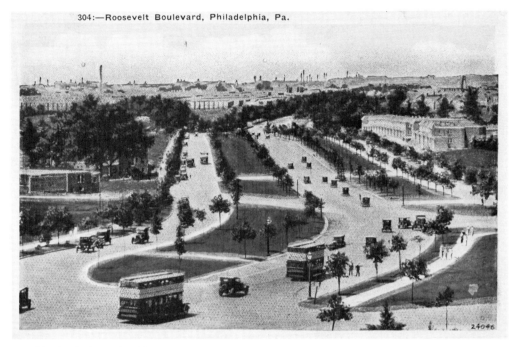

304:—Roosevelt Boulevard, Philadelphia, Pa.

Today, with virtually the entire 12-mile length developed into row houses, schools, and businesses, it is no longer quite so park-like.

This monumental 1920's brick-and-terra-cotta warehouse and store still dominates the Boulevard in Northeast Philadelphia. Workers here used roller skates to collect orders from the company's hugely popular mail-order

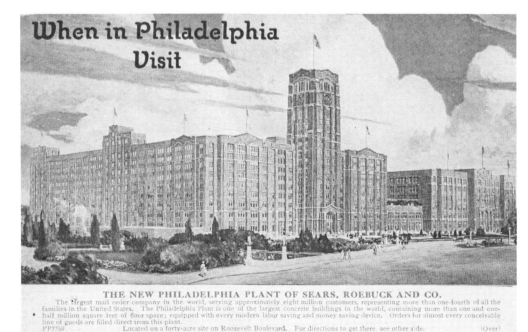

When in Philadelphia Visit

THE NEW PHILADELPHIA PLANT OF SEARS, ROEBUCK AND CO.

The largest mail order company in the world, serving approximately eight million customers, representing more than one-fourth of all the families in the United States. The Philadelphia Plant is one of the largest concrete buildings in the world, containing more than one and one-half million square feet of floor space; equipped with every modern labor saving and money saving device. Orders for almost every conceivable line of goods are filled direct from this plant.

PP7769 Located on a forty-acre site on Roosevelt Boulevard. For directions to get there, see other side. (Over)

catalog. As this card shows, the company encouraged tourists to drive or take a street car a bit off the beaten path to see their operation. Although not clear in this view, the central tower of this building supports a large clock.

Like Stetson and a few other large companies, Sears built houses for their executives on what was then largely undeveloped land.

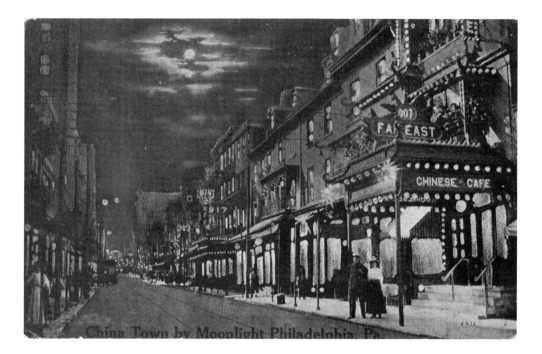

Chinatown, Race Street, 1916: The Chinese influence here began about 1870 when a Chinese laundry opened at 9th and Race Streets. Eventually, the entire area on Race Street from 8th to 11th Streets became known as Chinatown and remains so today. The attraction here has long been the neighborhood's many fine restaurants, the first of which appeared in 1880. At the time this card was sent, it was common to see Oriental men in silk robes smoking long silver-bowled pipes. Today, the area has retained its ethnic flavor, and numerous fine eateries continue to attract natives and tourists alike.

Historical Sites

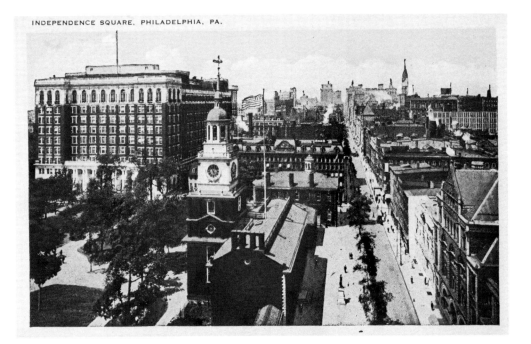

INDEPENDENCE SQUARE, PHILADELPHIA, PA.

Unlike most postcards of this period, this one shows the assortment of commercial buildings that surrounded Independence Square. Looking west along Chestnut Street, we see Independence Hall. Just beyond it is Congress Hall where the U. S. legislative branch first met. The tall structure to the left is the Curtis Publishing Company; to its right are the Public Ledger newspaper offices.

Beginning in 1948, the federal government and the Commonwealth of Pennsylvania acquired land east and north of the Hall, demolishing more than 200 buildings (including the ones on the right side of this view) to create Independence National Historical Park. The area was landscaped in the colonial style, and numerous historic structures were rehabilitated or recreated.

190?: The State House of Pennsylvania was constructed between 1732 and 1748 in the Georgian style. Edmund Wooley, a master carpenter, and Andrew Hamilton, a lawyer, served as architects, supposedly with inspiration from Joseph Gibbs' 1728 *Book of Architecture*. The tower and steeple were built in 1750, removed in 1781, and replaced again in 1828.

The building obtained its historical immortality in 1776 when it housed the Second Continental Congress, which signed the Declaration of Independence. In 1787, the United States Constitution was debated here, and the buildings were the seat of federal government until 1800. The connected buildings are Philadelphia's Old City Hall (left), which served that purpose until 1877, and Congress Hall (right) where Congress originally met.

Independence Hall, landmark though it is, has had a few close brushes with mortality. Just before the Civil War, plans were unveiled to build a new city hall on this spot, but voters rallied against the horrifying thought. During the Depression, the city was unable to maintain the building and sought to sell it to the U. S. government for $25 million. In 1948, a fire across Chestnut Street set off the Hall's sprinkler system. Finally, after decades of alterations and inept "restorations," the National Park Service spent 22 years replacing non-original hardware and fixtures. Today, Independence Hall is as close as it can be to what it was: the authentic birthplace of the United States.

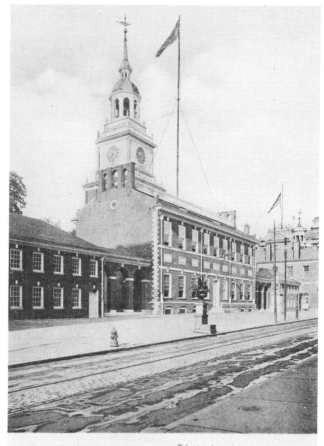

Independence Hall, Philadelphia, Pa.

No. 204. National Art Views Co. N. Y. City.

1915: Though built barely 50 years after the city's founding, Independence Hall is skillfully finished inside and out, as can be seen from these views. Before the National Park Service took charge of it, Independence Hall was maintained by the city as a museum of historical artifacts rather than as an exact re-creation of the building as it was in the 18th century.

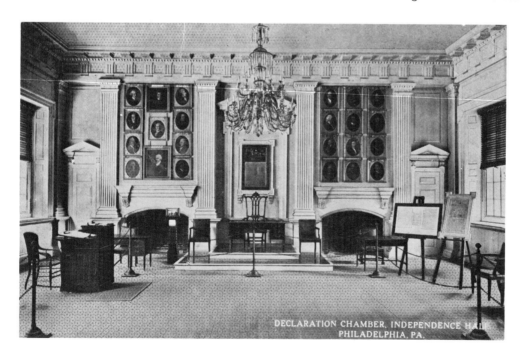

DECLARATION CHAMBER, INDEPENDENCE HALL, PHILADELPHIA, PA.

This is the Assembly Room where the Declaration of Independence was signed in 1776 and where the Constitution was drafted in 1787. In the center is George Washington's chair (the one with the famous "rising" sun carved on its back). To its right is John Hancock's more simple chair. The little display case before the left fireplace contains the silver inkstand used at the signing of both historic documents. It was purchased for use by the State Assembly in 1753 and cost 25 pounds, 16 shillings.

c. 1910: The Liberty Bell rang along with many other bells in the city to herald the signings of the Declaration of Independence and the Constitution, among other occasions. In fact, it rang so often and so loudly that neighbors presented a petition stating: "from its uncommon size and unusual sound, it is extremely dangerous and may prove fatal to those afflicted with sickness." Nevertheless, it continued pealing until a fatal crack appeared in it while sounding to recognize the death of Chief Justice John Marshall in 1835. When it was offered in partial payment to John Wilbank, a Germantown founder, for a new bell, he found moving it to be so expensive that he just left it where it was. Wilbank was sued, and finally donated the defective bell to the city, which accepted it rather reluctantly. Subsequently, the bell was sent on tours throughout the country where people would cut shavings from it for souvenirs. It has remained a stationary exhibit since 1917.

The bell is shown here mounted on a cart encased in a removable pedestal so that, in case of fire, one man could push it out of the building in two minutes. On December 31, 1975, the Liberty Bell was moved once again a few hundred feet into a new glass pavilion on the Mall where it can be viewed and touched by all (no souvenirs, please).

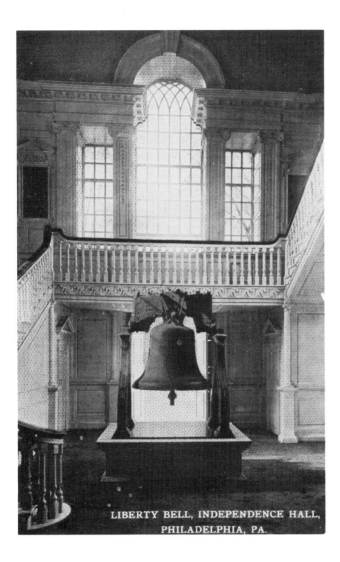

LIBERTY BELL, INDEPENDENCE HALL, PHILADELPHIA, PA.

Chestnut between 3rd and 4th Streets: No real architects in today's sense of the term were in Philadelphia in colonial days, and the carpenters themselves generally executed design details. This required not only basic mechanical skills, but a knowledge of the classical orders, mathematics, and so on. The Society of Carpenters was formed in 1724 by local master carpenters to gather knowledge on these subjects and to assist its needy members. A library was begun, and this meeting house opened in 1771. But history intervened and the new guild hall was borrowed by the first Continental Congress in 1774 to press their grievances against Great Britain (Independence Hall, then called the State House, was in use at the time). Three years later, General Howe's occupying troops used the Hall as a barracks and the weather vane (still on display), for target practice. Carpenter's Hall subsequently served as offices for the Secretary of War (1790–91); offices and vaults of the First National Bank (1791–97); and in 1824, the site of America's first manufacturers' exposition.

The building is about 50 feet square and built in the form of a Greek cross with a central cupola. The restored Hall is open to the public and still owned and maintained by the Carpenters' Company, which meets here four times a year.

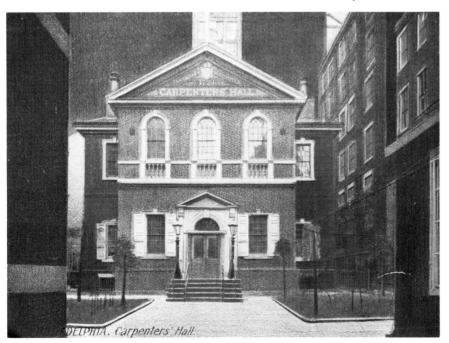

DELPHIA, Carpenters' Hall.

Arch Street, 1906: Mrs. Ross' fame began in 1870 when her grandson recounted a tale she told him about making the Republic's first flag. That story has never been proven, nor has the assumption that she lived in this rowhouse. The building was purchased in 1905 by small donations from over a million Americans and, in 1930, the buildings surrounding were demolished. A. Atwater Kent (the radio magnate) financed a complete restoration later in the 1930's, creating the somewhat less ostentatious structure seen today by over 300,000 visitors a year—second in tourist popularity only to the Liberty Bell.

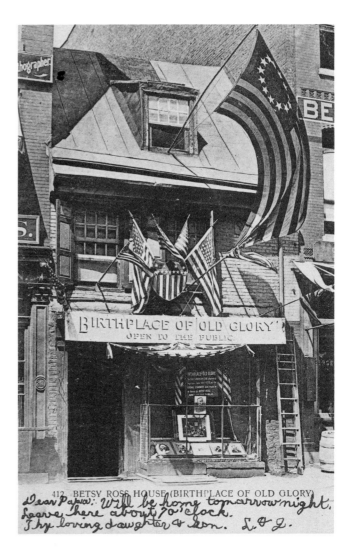

412 BETSY ROSS HOUSE (BIRTHPLACE OF OLD GLORY)

Dear Papa: Will be home tomorrow night. Leave here about 7 o'clock. Thy loving daughter & son. L. & J.

420 Chestnut Street: This building is best known today by its original name: The Second Bank of the United States. It was the first of many public buildings based on classical Greek models; the inspiration here was the Parthenon. William Strickland was the architect, and construction took six years, beginning in 1818. It served as a depository for the federal government until 1836 when it became the Pennsylvania State Bank for one year. The government bought the bank in 1844 and converted it into a custom house for the busy local port. This function ceased in 1930, and, after 20 years as the Carl Schurtz Memorial Foundation, it became a portrait gallery and part of Independence National Park.

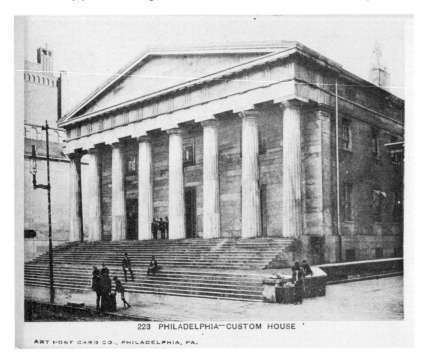

223 PHILADELPHIA—CUSTOM HOUSE

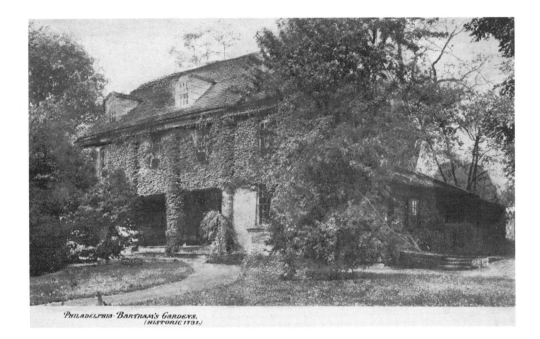

Philadelphia-Bartram's Gardens.
(Historic 1731.)

54th Street and Lindbergh Boulevard: John Bartram (1699–1777), America's first great botanist, gathered plant specimens from around the globe to grow on his 280-acre farm along the Schuylkill River. He built this 18-room house himself in 1728–1731, and an addition in 1770. The design was drawn partly from architectural design books and partly from Bartram's eccentric imagination. The windows are surrounded by carved stone, and rather crude Ionic columns form a recessed porch. Inside is a Franklin stove given to Bartram by his friend Benjamin Franklin.

Bartram was appointed "American Botanist to King George III" and is referred to by Linnaeus as "the greatest natural botanist in the world." After his death, the gardens were maintained by his son and, later, his son-in-law. The house and 44 acres were purchased by the city in the 1890's and restored in 1925. They are a part of Fairmount Park today and open to the public.

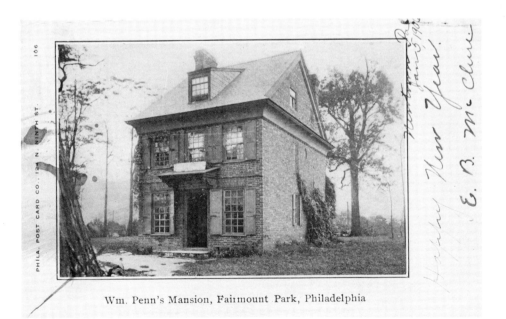

Wm. Penn's Mansion, Fairmount Park, Philadelphia

1906: This small brick house was dismantled and moved to a location near the zoo in 1883. It was long thought to have been the home of William Penn, but was actually built between 1713 and 1715, some years after Penn's last visit to the city. Today, it is called the Leticia Penn House after Mr. Penn's daughter (although she probably never lived here either). Regardless of original ownership, it remains a fine example of 18th century town house architecture; it is currently headquarters of the Wildlife Preservation Trust International.

5140 Germantown Avenue, 1908: Actually a small barn, this building is where the notable artist Gilbert Stuart painted General Washington's most famous portrait in 1796, not a particularly good view of which is shown on this card. The image proved so popular that Stuart was prevailed upon to produce quite a number of copies of it. After an eight-year stay in the city, Stuart left for Boston in 1802; the barn became a manufacturing shop and, later, a schoolhouse. Stuart often recalled Philadelphia as "the Athens of America."

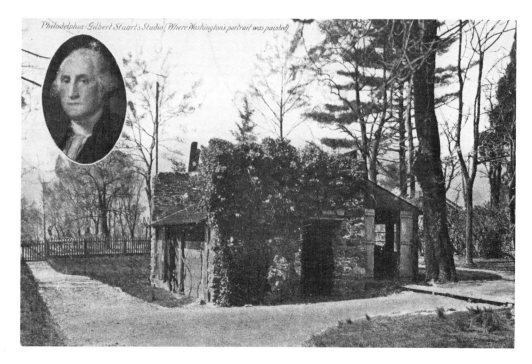

Philadelphia-Gilbert Stuart's Studio (Where Washington's portrait was painted)

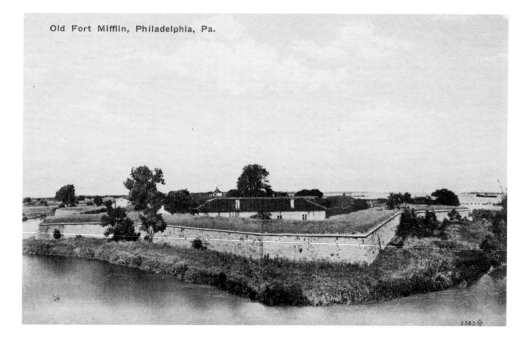

Old Fort Mifflin, Philadelphia, Pa.

Fort Mifflin (named for Thomas Mifflin, the Continental Army's quartermaster-general) was begun by the British in 1772 and completed by the colony's Committee of Safety by 1777. A last stand was made here against the powerful British Navy, which sent some 250 ships and 2,000 troops up the Delaware to take the city. The British finally prevailed at the cost of 250 rebel lives.

By 1798, the Fort was rebuilt under the direction of French military engineer Col. Louis de Toussard using plans drawn up by Major Pierre Charles L'Enfant (who later laid out the Capitol at Washington, D. C.). The fort was used during the Civil War as a prison for deserters but fell into disrepair after it was abandoned in 1904. In 1930, the entire complex, which includes a number of important and interesting architectural relics, was restored according to L'Enfant's original plans.

Today, the fort is open to the public and hosts re-enactments of military life.

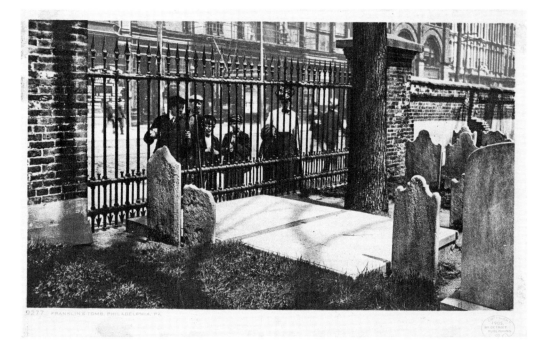

5th and Arch Streets: Mr. Franklin's tombstone says simply: "Benjamin and Deborah Franklin, 1790." Indeed, so numerous were his accomplishments, that a mausoleum would have been redundant. So many sightseers crowded the peaceful grave-yard at Christ Church that a section of the wall was replaced by an iron fence in 1858 to allow a better view from Arch Street.

Others buried in this two-acre churchyard include four signers of the Declaration of Independence, two Commodores of the Navy, and the first Treasurer of the United States.

Churches

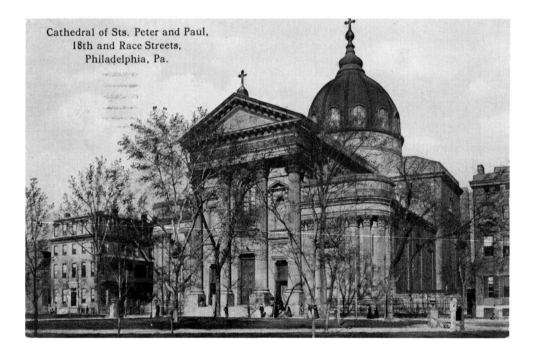

Cathedral of Sts. Peter and Paul,
18th and Race Streets,
Philadelphia, Pa.

1918: This Palladian Revival brownstone is the head church of some 300 congregations in the Philadelphia Archdiocese. It was built in 1846–1864 under the auspices of Rev. John Neumann and completed by his successor, the Rev. James Frederick Wood. Saint John Neumann is enshrined in a glass tomb here—the only saint in this country who can actually be seen. The impressive interior was planned by Napoleon LeBrun, who also designed the Academy of Music. Major renovations took place in 1914 and 1957.

Today, it still dominates the center of the Parkway, and the wooden benches and cool plantings provide a convenient pedestrian respite.

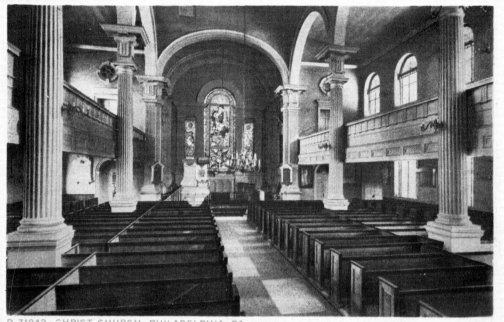

D-71042 CHRIST CHURCH, PHILADELPHIA, PA.

2nd and Market Streets: Constructed between 1727 and 1744, this church, unusually ornate for early Philadelphia, was the place of worship for the Penn family, Washington, Franklin, Lafayette, and Betsy Ross. The steeple was completed in 1854 with brick-faced stone walls four feet thick supporting a delicate wooden belfry and steeple with eight bells that rang with the Liberty Bell in 1776. The interior of the church was altered in 1834 by Thomas U. Walter (designer of the U. S. Capitol dome) and restored to its original appearance in 1881. The Palladian window above the altar was the first stained glass window in Philadelphia, and the burial grounds contain seven signers of the Declaration of Independence.

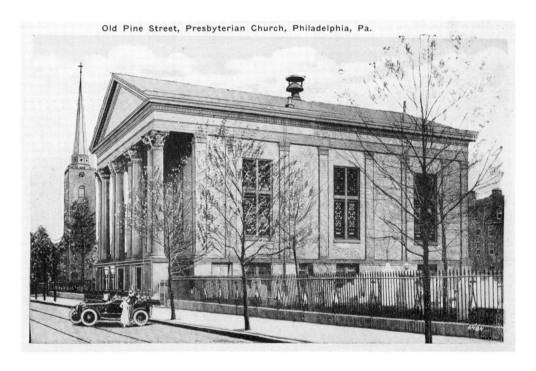

Old Pine Street, Presbyterian Church, Philadelphia, Pa.

422 Pine Street: This is the only Presbyterian church in Philadelphia remaining from the colonial period. It was built in 1766–1768 on land donated by William Penn's sons Thomas and Richard, and was used by the British as a hospital and cavalry stable during their Revolutionary War occupation. The pews were burned for fuel. John Adams attended church here as did William Hurrie, the man who probably rang the Liberty Bell on the day of America's independence. Many notables are buried here along with one hundred Hessian soldiers.

Swanson and Christian Streets, 1907: Built during 1698–1700, this is the oldest church in Pennsylvania and possibly the oldest building in Philadelphia. The Swedes settled here many years before Penn's arrival, and this building was erected only sixteen years after his ship, the "Welcome," first sighted land.

The church has been altered little over the centuries except for some interior modifications in 1846 (galleries added) and 1896 (three aisles added). Two ships hang from the ceiling, models of those that brought

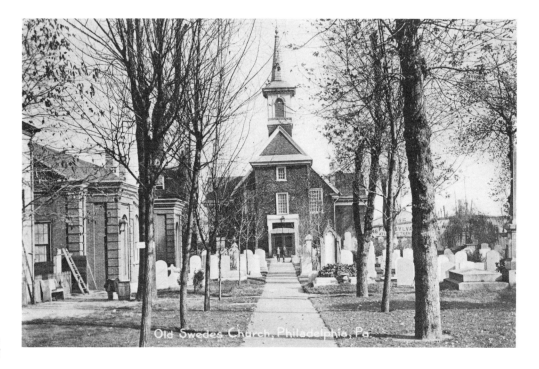

the first Swedish settlers to the New World; and the artifacts inside include Queen Christiana's 1608 Bible and some Jenny Lind memorabilia (she sang here in 1851). The oldest tombstone in the churchyard is dated 1708.

The church joined the state's Episcopal Diocese in 1845 and is now a part of Independence National Historical Park.

1910: This 1804 building in the unadorned Quaker style was designed by Owen Biddle on land donated by William Penn in 1693. The churchyard was originally used as a cemetery and more than 20,000 people are buried here. Many were victims of the 1793 yellow-fever epidemic that wiped out about one-tenth of the city's population. No one has been interred here for over 120 years, however.

The ground floor contains three large meeting rooms, and the plain benches were made from trees that were cleared from the site. This is the oldest Friends Meeting in the city and is still used regularly. The Philadelphia yearly meeting is held here each spring. The building houses some interesting exhibits and is open to all.

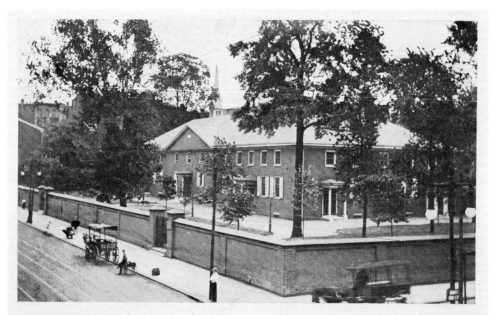

FRIENDS' MEETING HOUSE. Fourth and Arch Streets, Philadelphia. From the North West. Built 1804-1811

Grand Structures

According to Mr. Penn's original plans, Center Square was to be a public space right in the center of his new city where Broad and High (now Market) Streets cross. In 1800, a pump house designed by Benjamin Latrobe was built on the square in the Greek Revival style, which was much copied and admired. This was demolished in 1827 and the square remained undeveloped for 50 years.

Meanwhile, there was talk of building a new city hall to replace the cramped old one at Fifth and Chestnut, and a plan for a three-sided structure at Independence Square was unveiled in 1860. This intrusion onto sacred ground motivated the state legislature to enact a law protecting the historic area (owned by the city). Voters then chose Center Square as the least objectionable site for a new city hall, and ground was broken in 1871 under the direction of architect John McArthur, Jr., consulted by Thomas U. Walter.

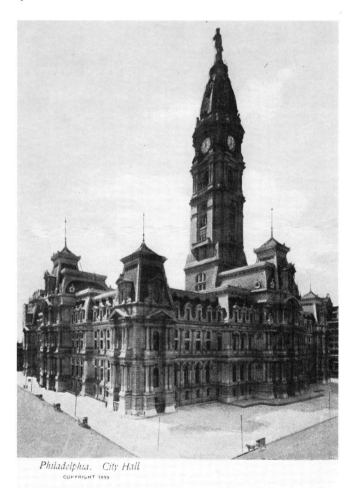

Philadelphia. City Hall
COPYRIGHT 1899

H. T. B.

The original plans called for a fairly modest tower, but McArthur decided upon more heroic proportions and extended the masonry and iron up to 584 feet—to this day, higher than any masonry building in the world except the 3-foot-taller Washington Monument. The huge marble and granite building occupied five acres, and took 30 years plus $2\frac{1}{2}$ times its projected cost to complete. In fact, construction took so long that the second Empire architectural design had gone out of style and both original architects had died of old age before the building was fully occupied.

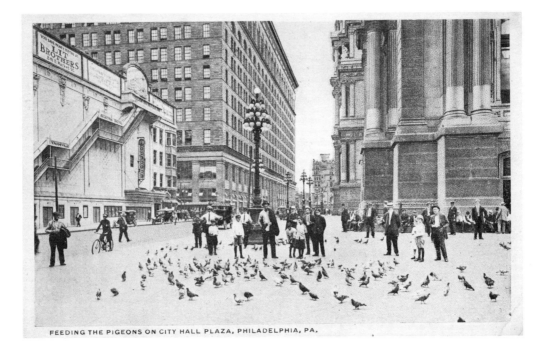

FEEDING THE PIGEONS ON CITY HALL PLAZA, PHILADELPHIA, PA.

1917: Despite the controversy over delays, graft, and ostentation, City Hall worked itself into the hearts of most Philadelphians and is now as much a part of the city as the Liberty Bell and the soft pretzel. Seventeen years after this photograph was taken, the entire building was shifted onto a new foundation to allow the Market-Frankford subway to run underneath. Heavy steel beams were inserted in the old masonry to transfer the massive structure onto a new foundation 20 feet below the old one. Here we see the northeast corner of the Hall.

The large building with all the windows is Wanamaker's Department Store; the building to the left is the Globe Theatre.

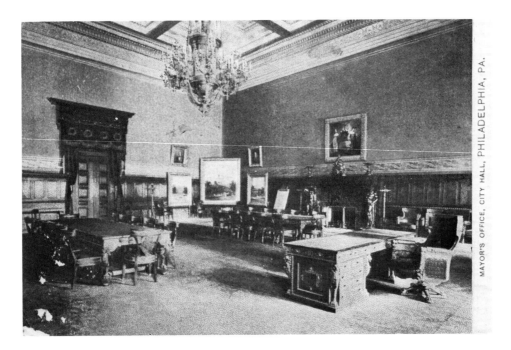

MAYOR'S OFFICE, CITY HALL, PHILADELPHIA, PA.

1908: This is but one of many opulent rooms in City hall, most of which have been restored to their original condition.

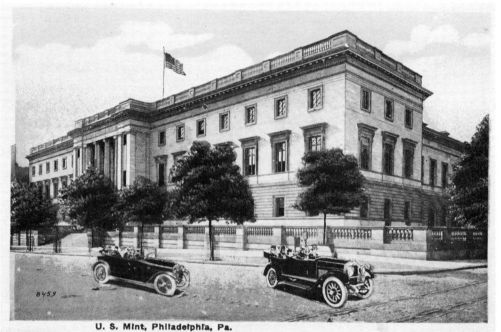

U. S. Mint, Philadelphia, Pa.

Spring Garden Street between 16th and 17th Streets: The first U. S. mint was established at 7th and Filbert Streets in 1792 with a horse-powered rolling mill. By 1833, steam power had taken over, and a new mint was designed by William Strickland at the northwest corner of Chestnut and Juniper Streets (above).

Strickland was one of the most influential architects of his day. He designed, among other buildings, the Second Bank of the United States and the Merchants' Exchange. Joseph Chandler, publisher of the *United States Gazette* said of Strickland: "He found us living in a city of brick, and he will leave us in a city of Marble." Sadly, only three of Strickland's buildings survive (the two mentioned previously plus the U. S. Naval Asylum), and the mint is not one of them. It was demolished and replaced by the Widener Building.

Opened in 1901, the next mint (see below) located on Spring Garden Street at 16th and 17th, was a solid granite Beaux-Arts style structure designed by James Knox Taylor. The lobby had seven Tiffany mosaic murals by William B. Van Ingen.

This building was one of the more popular tourist stops in the city, and produced 65 percent of all U. S. coinage as well as coins for numerous South American countries and Cuba. It also assayed metals for private owners. The workers walked on metal grates, and all gloves and towels were burned and washed in a special bath to recover precious metal waste.

The building was vacated in 1969 and is now used by the Community College of Philadelphia. The mosaics were moved to the newest mint (at 5th and Arch Streets) in 1971. The Philadelphia mint still produces most United States coins.

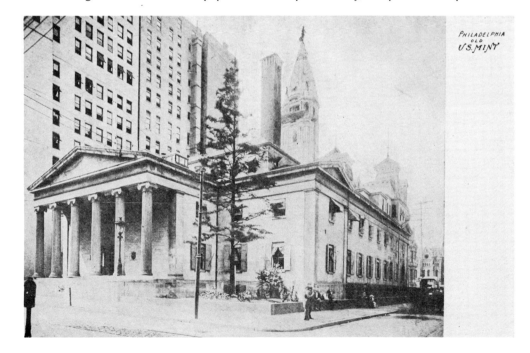

PHILADELPHIA
OLD
U.S. MINT

MASONIC TEMPLE, PHILADELPHIA, PA.

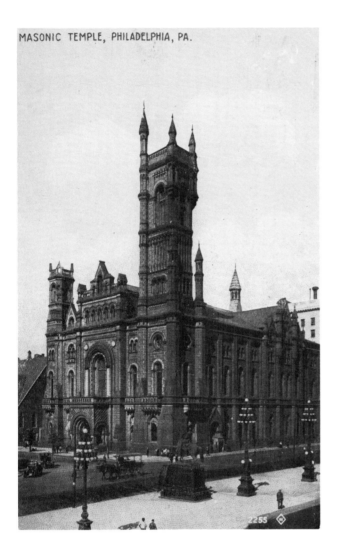

1 North Broad Street, 1914: This Romanesque-style lodge was opened in 1873 and is currently the headquarters for the Free and Accepted Masons of Pennsylvania. It was designed by 27-year old James H. Windrim (himself a Mason) and is somewhat of a tour through the history of architecture.

The seven lodge halls are based on various periods: Ionic, Italian Renaissance, Norman, Gothic, Oriental, Egyptian, and Corinthian (shown below). The hieroglyphs in the Egyptian Hall were copied from eight Egyptian temples. Its throne is gilded ebony flanked by sphinxes. Oriental Hall is in a Moorish style and was formed from over 20,000 pieces of fiber and plaster board screwed to the walls and ceiling.

The collections include a Masonic apron embroidered by Madame Lafayette and worn by George Washington when he laid the cornerstone of the Capitol Building in Washington, D. C.

Tours of this marvelous building are offered to the public.

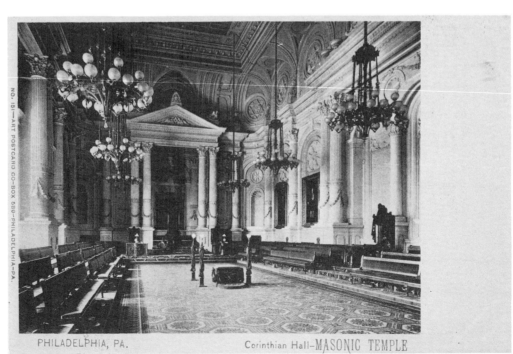

PHILADELPHIA, PA. Corinthian Hall—MASONIC TEMPLE

Courtyard of City Hall, 1908: City Hall is literally covered with some of the most lavish and imaginative sculpture of its time, all supervised by Alexander Milne Calder (grandfather of Alexander Calder, creator of the mobile, among other things). The crowning touch was a 37-foot bronze sculpture of the city's founder assembled atop the tower from 14 sections. Here, it can be seen on display in the City Hall Courtyard. Looking down the Benjamin Franklin Parkway to City Hall, the work of three generations of Calders are on display.

Broad and Chestnut, 1910: Here is a Frank Furness-designed building in a Classical style modelled after the Pantheon in Rome. The Columbian Exposition in Chicago inspired many buildings of this type. It was built during 1905–1908 with a steel frame and marble walls, and has an impressive two-story main room with adjoining galleries.

On the Broad Street side (right of card) is a sculptured relief of two sailing ships and a profile of the bank's namesake—Stephen Girard (see "Girard College" on page 102). The building (now Mellon Bank) remains, and is one block south of City Hall. A tall, although harmonious, addition replaced the building seen here on the right in 1931.

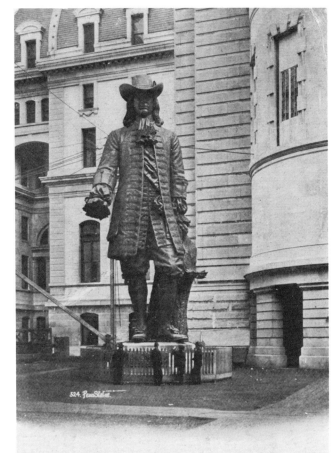

3418—William Penn Statue, Philadelphia, Pa.

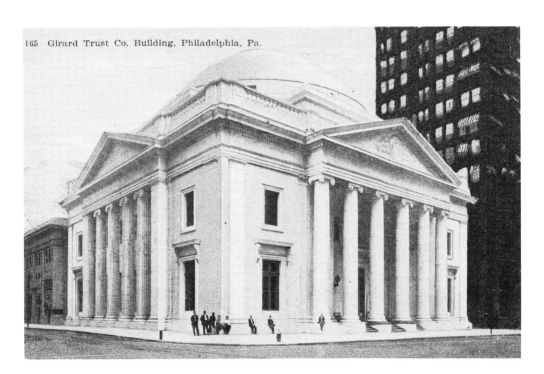

165 Girard Trust Co. Building, Philadelphia, Pa.

Fairmount Avenue: Quaker reformers of the last century believed that prisoners, given a secluded room and a Bible, and kept occupied with handicrafts would become useful members of society. These good intentions failed to provide much in the way of reform, but architect John Haviland's 1823 prison plan had two unique features that were much copied: a Gothic, castle-like facade and a radial cellblock plan. The 8-foot by 10-foot cells radiated out

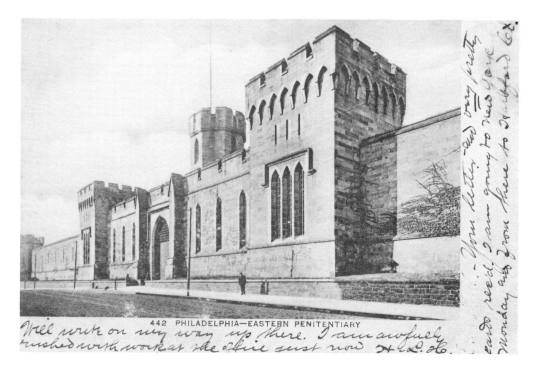

442 PHILADELPHIA—EASTERN PENITENTIARY

from a central "hub" like the spokes of a wheel. This allowed guards in the center to view and control all the cells. The forbidding 35-foot granite walls with their impregnable battlements surrounding eleven-and-a-half acres were models for many houses of reform.

After 150 years, this prison was vacated in 1970 and remains empty and all the more forbidding today. Various plans are being considered to adapt the complex for some other use.

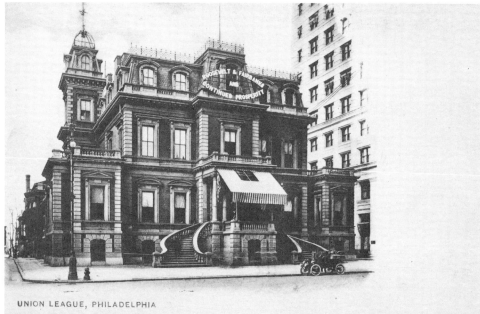

UNION LEAGUE, PHILADELPHIA
W. N. Jennings, Photo.

Broad and Sansom Streets, 1904: The Union League was founded in 1862 by men with "unqualified loyalty to the government of the United States and unwavering support of its measures for the suppression of the Rebellion." Its members gathered 10,000 volunteers and $500,000 for the Union cause. Though previously three-quarters Democrat, it was made exclusively Republican in 1898. The sign above the entrance is for the Presidential election of 1904, won by Theodore Roosevelt and Charles W. Fairbanks. Women were allowed membership in 1986 by a vote of 920 to 426.

This brownstone and brick clubhouse was opened in 1865 and remains an impressive, if somewhat out-of-place monument about a block south of City Hall. It has had numerous renovations but remains essentially unchanged on the exterior, except for the mansard roof of the tower and the iron fencing on the main roof. The League's somewhat somber appearance inspired Philadelphia wit Alfred Bediner to suggest the building be hung with black crepe to cheer it up.

11–21 South 5th Street, 1906: This steel frame-and-sand-stone building was designed after similar European structures by G. W. and W. D. Hewitt, and was the country's first merchant's exchange when it opened in 1895. Its 1,500 members traded goods and services in a balconied central floor lit by a skylight. This activity continued until the Depression. In 1978, the entire building, with its marble stairways and seven-story atrium, was remodeled into a unique shopping mall.

8189 THE BOURSE. PHILADELPHIA. PA.

1906: William Strickland, celebrated for his Second National Bank building, designed the Stock Exchange (also called the Philadelphia Exchange Company or Merchants Exchange) to fit an unusual triangular-shaped lot near Independence Hall. His inspiration was the choragic monument of Lysicrates in Athens. The marble work was done by Philadelphian John Struthers, and the lions on each side were imported from Italy in 1838.

Formerly, local merchants had to make business deals in taverns or whatever meeting places were available. The exterior was restored in 1965, although the interior is not currently open to the public.

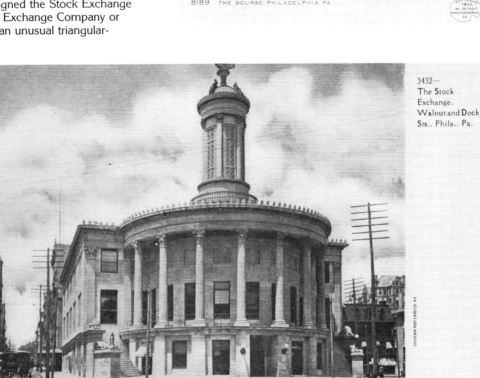

3432—
The Stock Exchange,
Walnut and Dock Sts., Phila., Pa.

Early skyscrapers, South Broad Street: Despite Philadelphia's conservative reputation, it hardly lagged behind other cities in the construction of new steel-framed "skyscrapers," many of which were built in the first couple of blocks south of City Hall on Broad Street. The 1891 Betz Building (right) was among the first American buildings of its type and the first skyscraper in Philadelphia. It is 212 feet high with 13 stories. Height did not always mean beauty to some. One critic in the *Architectural Record* described it as a "bastard Richard-sonian type". Parentage aside, it still stands.

BETZ, GIRARD & REAL ESTATE TRUST BUILDINGS. PHILADELPHIA, PA.

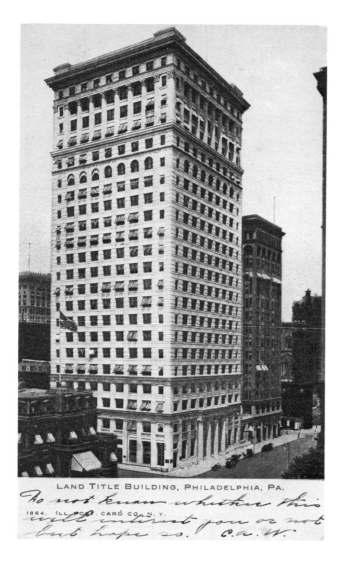

LAND TITLE BUILDING, PHILADELPHIA, PA.

1864. ILL. POST CARD CO. N.Y.

The 22-story Land Title Building, located on the southwest corner of Broad and Chestnut (left), was built in 1898 on the former sites of the Academy of Natural Sciences, the First Baptist Church, and the Hotel Lafayette. The smaller addition was constructed in 1902. The Chicago firm of D. M. Burnham & Company was its designer—and among the first "outsiders" to design a major Philadelphia building. The classically-inspired skyscraper housed the world's oldest title insurance firm and bears a close resemblance to the Fisher Building, which the same architects built in Chicago the previous year. Note the awnings on the south side. With some modernization, it still stands today.

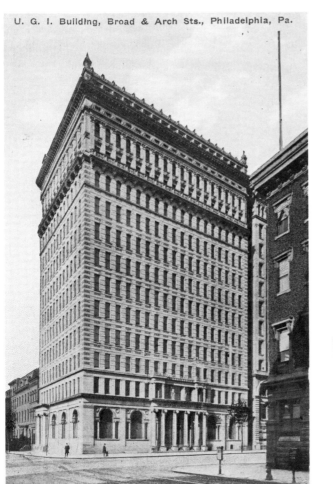

U. G. I. Building, Broad & Arch Sts., Philadelphia, Pa.

2329

Another First Baptist Church was demolished to erect the U. G. I. Building at Broad and Arch Streets in 1898 (left). The United Gas Improvement Company controlled not only the gas service to the city, but interests in electricity and public transportation as well. It used its influence to gain lucrative contracts with the city and to fill the pockets of certain unscrupulous politicians. U. G. I. was used as a model for the Sherman Anti-Trust Act and encouraged a movement for political reform. Since this card was printed, the building has doubled in width, increased in height, and lost its colonnaded entranceway as well as its owner, which was absorbed by the Philadelphia Electric Company.

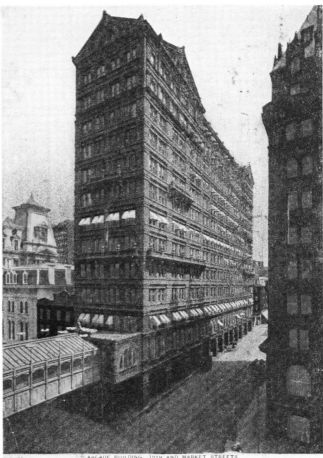

ARCADE BUILDING, 15TH AND MARKET STREETS
PHOTO. & ART P. C. CO., N. Y. PHILADELPHIA, PA.

Am too busy to write any letters at present, so this will have to do. Hurry up and ... not that in ...

The 1902 Arcade Building (right) at 15th and Market was financed largely by the Pennsylvania Railroad. Furness, Evans & Company were the architects, although this design shows none of the famous Furness eccentricity. The elevated walkway connected the building with Broad Street Station. This facility for pedestrian traffic and provisions for additions to the structure as new property was acquired make the Arcade Building unusual. A 21-story tower was added to the original thirteen stories in 1913 (this card is dated 1906), and further additions were made in 1930. The building was demolished in 1969 to make way for the massive Penn Center renewal project. City Hall can be seen to the left in this view.

Other early skyscrapers that still stand are the Bellevue-Stratford Hotel (1904), and the John Wanamaker Department Store (1902). Despite what must have seemed dizzying heights at the time, no Philadelphia building looked down upon City Hall's statue of William Penn until 86 years later when One Liberty Place was built at 17th and Market.

1914: This was one of the properties left by financier Stephen Girard to the city, and until 1907, it was the location of several local business institutions including Frederick Brown's Drug Store, Warburton the Hatter, and Moss Stationery. Brown's refused to bow to the mechanical bustle of the new century and, even in 1906, customers found comfort in its 19th century atmosphere.

Eventually, it was decided to raze the entire area, and the result was the ten-story Lafayette Building with John T. Windrim as its architect. It provided the latest in business accommodation: ice water piped into each office, central vacuuming, and telephone plus ticker-tape service.

Under Girard's interesting will, funds were provided to light Delaware Avenue and Front Streets between Vine and South Streets, and a generator in the basement of the Lafayette Building did just that until 1950. In 1954, the Board of City Trusts sold the Lafayette building (which still stands) for $1.5 million. The Girard Trust continued to pay the light bills, but the city provided the bulbs.

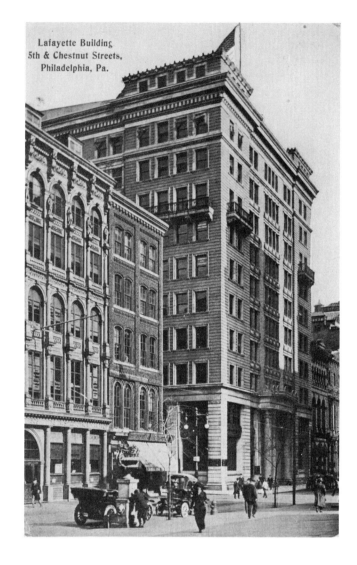

Lafayette Building
5th & Chestnut Streets,
Philadelphia, Pa.

Northwest corner of Broad and Market Streets: This was the largest railroad passenger terminal in the world when it was built. The northern section (to the right of this view from City Hall) was completed in 1882; the taller section, in 1892. The architects were Wilson Brothers & Co., and Furness, Evans & Co., respectively.

The terra cotta sculpture and the interior plaster bas-relief work were done by sculptor Karl Bitter. The train shed in the rear had the largest permanent roof in the world with a 300-foot, 8-inch span. The shed was completed in 1902 and destroyed by fire in 1923.

The sculpture "Spirit of Transportation" was moved to 30th Street Station in 1933, and the Philadelphia Orchestra gave the station a special farewell performance before its demolition in 1952.

Today, the site is occupied by office buildings and, below ground, the 15th Street subway station. Claes Oldenburg's 1976 statue of a giant clothespin is now just across Market Street, to the left of this view.

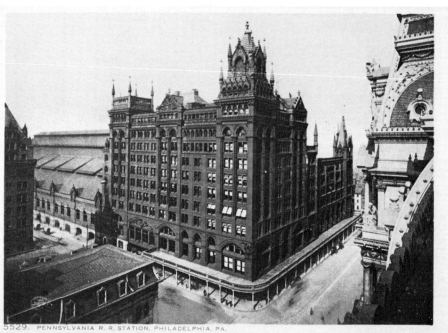

5529. PENNSYLVANIA R. R. STATION, PHILADELPHIA, PA.

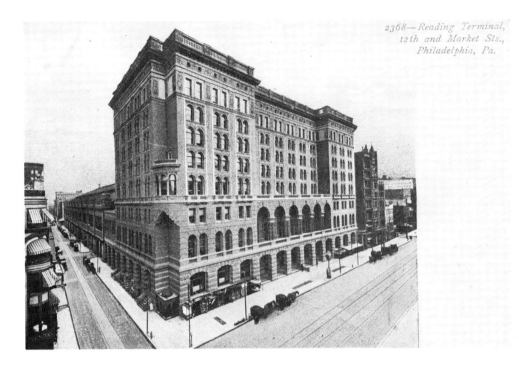

1907: This salmon brick and terra-cotta building was designed in 1891 for the Reading Railroad by Harry Francis Kimball. The last train pulled out of the shed in 1984, and current plans are to incorporate the structure into a new convention center.

However, the real purpose of this somewhat stern building, at least according to several generations of Philadelphians, is the Reading Terminal Market in the first floor rear (on the left side in this view, along Twelfth Street). This combination old-style farmer's market and nouveau food store is something everyone is loathe to lose.

A portion of the Hotel Vendig is visible to the left.

30th Street Station, 1930: The Pennsylvania Railroad station that opened in 1933 bore little resemblance to this drawing, but was designed in a more conservative classical style rather like the new Post Office to the left. Its architects were Graham, Anderson, Probst & White.

Before this station and its connecting lines were built, railroad tracks ran straight down Market Street atop the monolithic "Chinese Wall" to the old Broad Street Station across from City Hall. This eyesore had long outlived its usefulness when it was torn down in the early 1950's along with its noble, but out-dated, station.

Despite the change in design, the new station at 30th Street remains an impressive and useful facility today. The main concourse (recently restored) has a 94-foot gold coffered ceiling with ten 18-foot long chandeliers. Much of the interior is of Italian travertine limestone and measures a total of 328 feet by 638 feet.

With the failure of the huge Pennsylvania Railroad, the terminal was taken over by the federal government. The buildings shown behind the station are mostly from the artist's imagination, although there has been talk of increased development in this area.

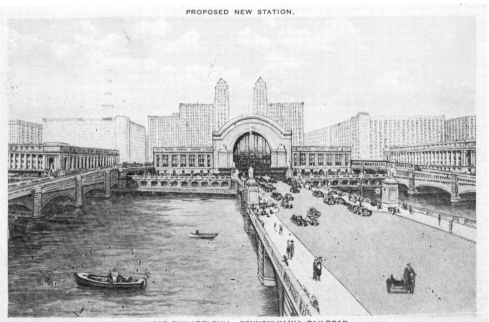

PROPOSED NEW STATION,

WEST PHILADELPHIA, PENNSYLVANIA RAILROAD.

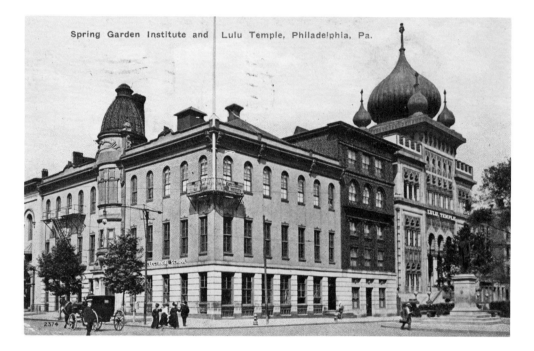

Spring Garden Institute and | Lulu Temple, Philadelphia, Pa.

Broad and Spring Garden Streets: The Spring Garden Institute, started in 1851, was the first manual training school in the U. S. (note the "Electrical School" sign). This building, designed by Hoxie & Button, was opened in 1852. The first floor was sheathed in iron that simulated brownstone. In 1892, the copper-clad tower above the entrance was added, and the ground floor, formerly retail space, was remodelled into a library. The northern (left) section of the building was the Apprentice's Library from 1897 until 1946, the oldest free library in the country. The building was demolished in 1972.

The exotic Lulu Temple, opened in 1903, was quite a popular postcard subject. It was of Moorish-inspired design and home to the Ancient Arabic Order, Nobles of the Mystic Shrine (or, more popularly, "Shriners"), founded as a sort of "playground" for Freemasons, complete with exotic Arabian mystic rites and dress. The marble and terra-cotta building contained, among other amenities, a bowling alley, a billiard room, and a pipe organ.

The organization proved so popular that, fourteen years later, plans were underway to build a $1 million Temple across from the Philadelphia Museum of Art. When these plans fell through, the group purchased the Metropolitan Opera House at Broad and Poplar Streets in 1922. Plans to restore this building never materialized and, in 1945, the Temple shown here burned to the ground. In 1948, the Shriners bought the Commodore Hotel at Broad and Spruce Streets (later the Philadelphia Musical Academy), and in 1968, a new temple was finally built, although it was outside the city near Plymouth Meeting. The Shriners still meet there today.

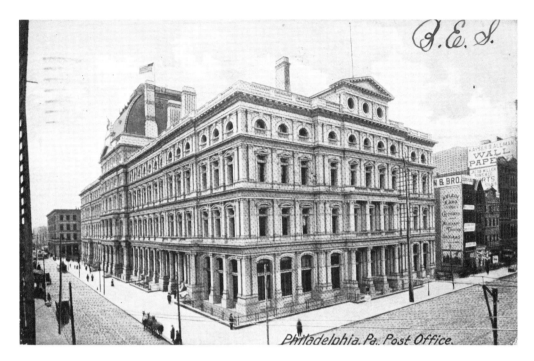

Philadelphia. Pa. Post Office.

9th and Market Streets, 1906: This site was occupied by the University of Pennsylvania from 1802 to 1873 when the cornerstone to the new Post Office was laid. Alfred B. Mullett was the architect of this, Philadelphia's twenty-second post office. It was completed in 1884. In front of the mansard roof was a Daniel Chester French sculpture *Law, Prosperity and Power.* John McArthur, Jr., the project's supervisor during its eleven years of construction, worked simultaneously on another big project: the new City Hall.

The Post Office was demolished and replaced by the more Spartan United States Court House in 1940, and a new post office opened at 13th and Market in 1935 at a cost of $6,650,000. French's sculpture was moved to George's Hill in Fairmount Park.

South Broad and Chancellor Streets: The Art Club consisted of local artists as well as amateurs from the business and professional community. Architect Frank Miles Day had just returned from a trip to Europe with sketch books filled with ideas when he received his first important commission, and the result might have fit as well on the sunny Riviera as on Broad Street. Day designed the Art Club's 1886 four-story clubhouse in the French Renaissance style and built it of brick, limestone, and terra cotta.

The *Architectural Record* gave this critique: "Weak it is in mass, composition and scale, but every line of it is refined and sensitive as possible."

The sun no longer shines through its balcony, however. It was torn down in 1976 and replaced with a rather insensitive parking lot.

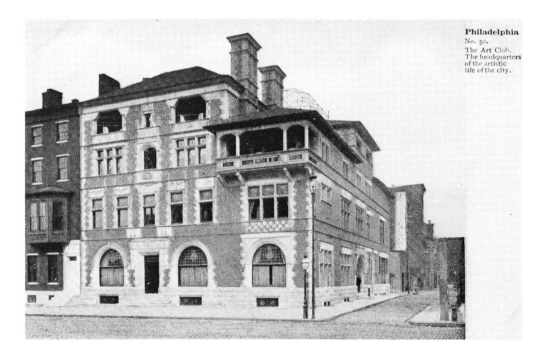

Philadelphia
No. 50.
The Art Club.
The headquarters of the artistic life of the city.

23rd and Ranstead Streets, 1900: The First Troop, Philadelphia City Cavalry, or "First City Troop," is the oldest active military organization in the country. It was founded in 1774 and attracted professional men, ship owners, importers, and traders. Like a number of similar units, it served the social as well as the patriotic needs of its members.

The founders of the Troop selected their own officers and then offered their services to the Continental Congress, distinguish-

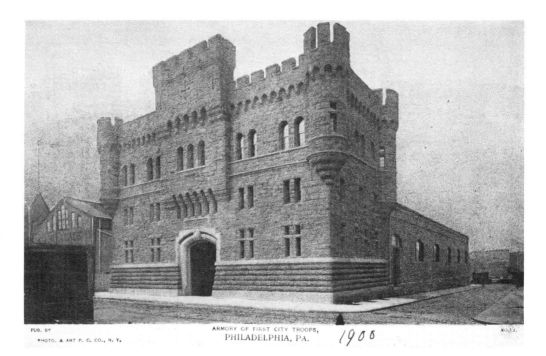

PUB. BY
PHOTO. & ART P. C. CO., N. Y.
ARMORY OF FIRST CITY TROOPS,
PHILADELPHIA, PA. *1900*
NO.

ing themselves in the Revolutionary War and every subsequent conflict involving the U. S. Whenever General Washington entered the city, he was sure to be lead with great pomp by the First City Troops.

Their first headquarters were at 1st and Ash Streets, but in 1899, when the roof collapsed during a snowstorm, this new and larger building was prepared. The first floor was a riding hall (the troopers rented their steeds from the many local livery stables for the weekly drills). Though less concerned with horsemanship, the First City Troop is still headquartered here as a Reconnaissance Company in the 28th Infantry Division of the Pennsylvania National Guard.

In 1907, the city opened its first subway line, connecting the Market Street Elevated Railway (popularly called the "EL") to the Delaware. Within ten years, the formerly bucolic suburbs of West Philadelphia were transformed into bustling residential districts. Yet, by 1912, the city had only about fifteen miles of high-speed rails while Chicago had ten times that, and New York had twenty times as much. Efforts begun by Transit Director Merrit Taylor succeeded in adding about 45 miles of additional track by the 1920's.

Today, the Market Street EL is still in operation along with the north-south Broad Street Line and the Frankford EL. The cars pictured here were in use well into the 1970's but have now been replaced with more modern stock.

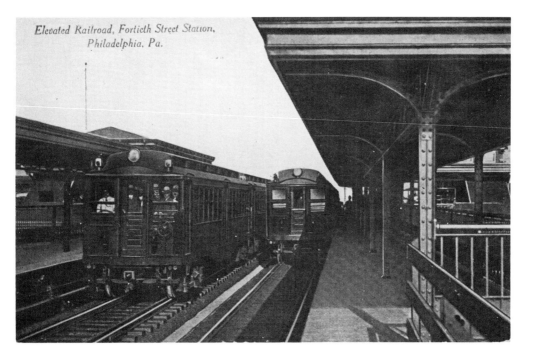

Elevated Railroad, Fortieth Street Station, Philadelphia, Pa.

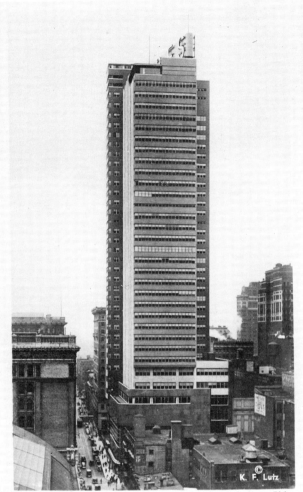

Philadelphia Saving Fund Society Bldg.

12th and Market Streets, 1932: The cut-off date for this book is stretched a bit by including this card, but the PSFS Building is just too important to leave out. Probably the first "modern" skyscraper in the U. S., it used the most up-to-date materials and technology, including stainless steel and cental air-conditioning. It was designed in 1930 by architects Howe & Lescaze and comprises 32 stories of polished granite with glass curtain walls. The 27-foot neon letters have been a local landmark for over half a century; another of the building's attractions is the panoramic view from the building's top-floor observation deck. In 1969, the Philadelphia Chapter of the American Institute of Architects judged this to be the "Building of the Century."

Fairmount and Other Parks

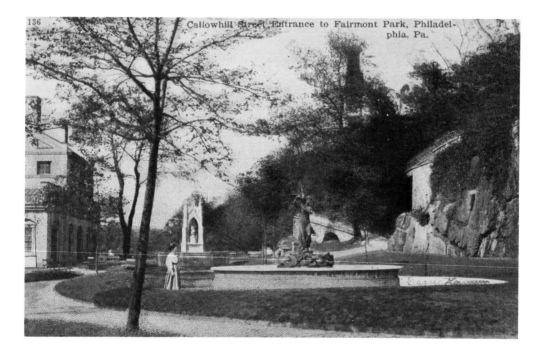

1911: On September 15, 1855, Lemon Hill, just north of the water works, was set aside as a public trust to protect the city's water supply. This also marked the beginning of the 8,700-acre Fairmount Park, the largest city park in the world. After the Civil War, the park became the city's great playground with miles of scenic carriage paths; concerts; a 2200-foot toboggan slide (opened 1887); and beginning in 1896, a seven-mile trolley line. Steam excursion boats plied the Schuylkill River as monuments by the dozen were dedicated.

This lovely entrance to the park displayed a fountain with William Rush's 1809 statue "Water Nymph and Bittern," one of first such displays in the country erected with public funds. (The first was Rush's "The Nymph of the Schuylkill," erected in Center Square two years earlier.) The Nymph balances on a rock while her bittern (a type of heron) spews water into the air. The fountain has been placed in storage by the Park Commission, and there are no immediate plans to display it.

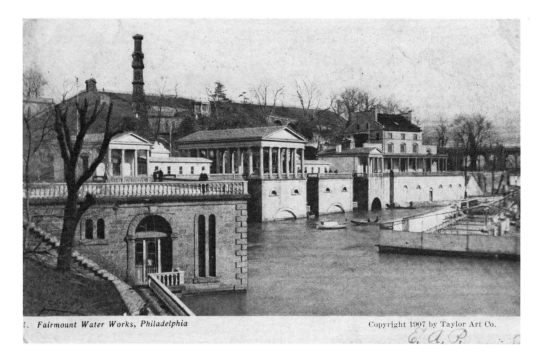

Fairmount Water Works, Philadelphia Copyright 1907 by Taylor Art Co.

Schuylkill River near 25th Street, 1907: In 1805, Frederick Graff was appointed superintendent and engineer in charge of the Philadelphia waterworks, a picturesque, although inadequate, structure where City Hall now stands. In 1812, construction began on a new type of steam-powered pumping system designed by Graff to be located along the Schuylkill River northwest of Center City. He replaced the old hollow wooden water pipes with iron pipes, and installed fire hydrants and valves to control the water flow and allow for repairs. The Fairmount Waterworks, completed about 1834 and in use until 1911, was and remains a major architectural and engineering landmark. Graff's innovations were followed by about 35 other American cities.

The 1852 Italianate water tower and reservoir behind the Waterworks were replaced by the Philadelphia Museum of Art, which now displays the two original sculptures carved for the waterworks by William Rush. The Waterworks is now being restored.

1906: Here, along the Wissahickon Creek, is a nicely preserved 18th century farmhouse that was home to Thomas Livezey III —a miller, poet, and statesman who purchased it in 1747. The house was built between 1733 and 1739. The boxy additions to the right were typical of these types of homes. As the family grew, so did the house. The second story was added to the main section about 1765.

The building was acquired by the Fairmount Park Commission in 1869 and has been home to the Valley Green Canoe Club since 1909. It remains romantic to this day.

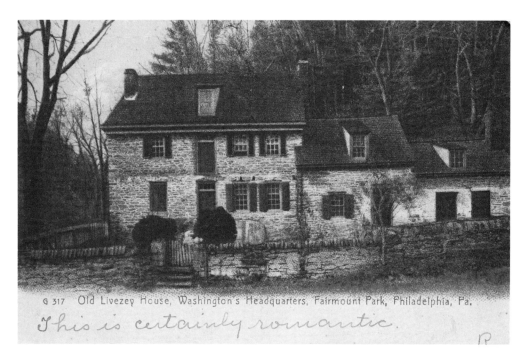

G 317 Old Livezey House, Washington's Headquarters, Fairmount Park, Philadelphia, Pa.

This is certainly romantic.

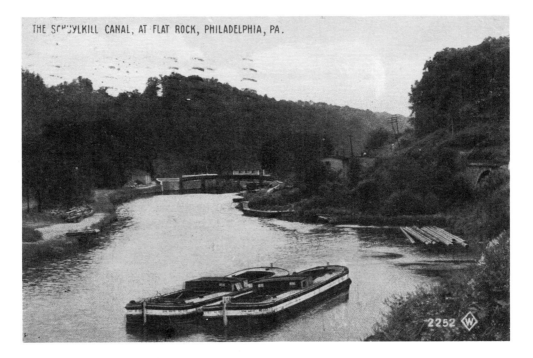

Before the locomotive, water travel was the most practical mode of transporting heavy loads of coal and grain, as well as being more comfortable than rickety stagecoaches. The 108-mile Schuylkill Canal was completed in 1825, connecting Philadelphia to Port Carbon north of Reading. It had 129 locks, 34 dams, a 385-foot tunnel, and a total rise of 610 feet. Barges towed by a single horse could reach the city in four days, and passenger boats could travel the distance in two days. Travellers to Reading caught coaches at the White Swan Hotel on Race Street above Second Street that took them to the canal boats at Fairmount. The fare was two dollars.

A bend in the Schuylkill created an island that came to be called "Belmont Landing." Barges like the one pictured below ran on the west side of the river and tied up near Montgomery Drive and Black Road.

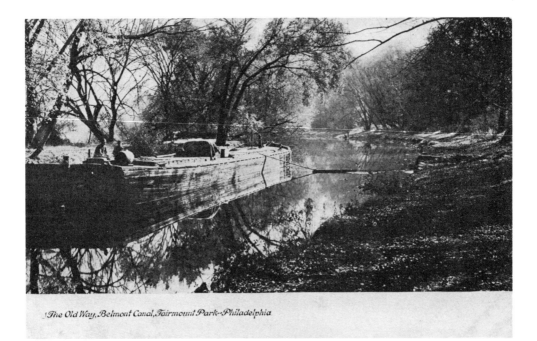

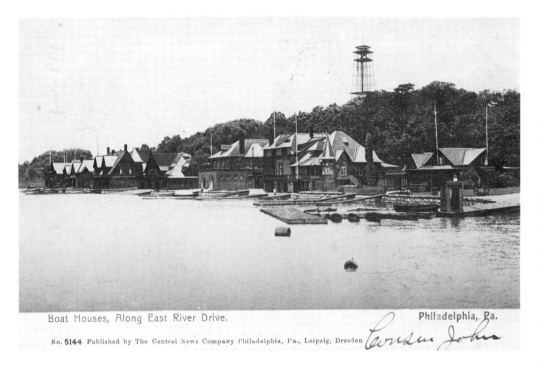

Boat Houses, Along East River Drive. Philadelphia, Pa.

No. 5144 Published by The Central News Company Philadelphia, Pa., Leipzig, Dresden

1905: The tranquil and wide Schuylkill River has long been an attraction to rowers, and by the 1850's, their rude shelters began to be replaced with more substantial structures. Each of these fanciful buildings (eleven of them survive today) is headquarters for a different rowing club. All except one are made of brick or stone. Some notables are the Undine Barge Club (built in 1883) designed by Furness & Evans, and the Malta Boat Club (built in 1870) designed by G. W. & W. D. Hewitt.

Numerous local high schools and colleges use these facilities, and races can be seen from stands and park areas on shore. Rows of temporary lights outlining the buildings at night for the 1976 Bicentennial proved so popular that permanent fixtures were installed in 1988.

The tower in the rear is the Lemon Hill observatory, which has since been demolished (see page 46).

1907: This road still offers a pleasant view of the Schuylkill River and the back of Boathouse Row, since 1853 the home of the local rowing clubs. The rustic tunnel remains, although it is now over Kelly Drive, named for Jack Kelly, a prominent oarsman and civic leader until his death in 1985. His sister was another prominent Philadelphian named Grace.

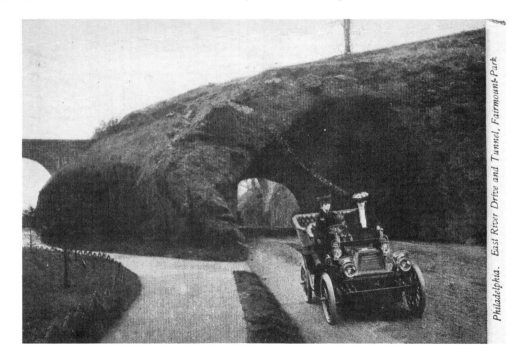

Philadelphia. East River Drive and Tunnel, Fairmount Park.

Boat racing on the Schuylkill, as popular now as ever, may be seen almost every weekend in suitable weather. Among the larger events are the May Day Regatta (the largest such collegiate event anywhere) and the Independence Day Regatta. During these festive occasions, scores of racing boats ("sculls"), costing up to $10,000 each, may be seen in competition.

The Schuylkill River got its name from the Dutch word meaning "hidden stream." The rowing community here is referred to as the "Schuylkill Navy."

Regatta Day, Schuylkill River, Fairmount Park, Philadelphia, Pa.

1917: This is a Nio-mon, or Japanese temple gateway, which was originally exhibited at the St. Louis Exposition of 1904. It was presented to the city by John H. Converse and Samuel M. Vauclain shortly thereafter. The gate measured 45 feet high, 30 feet wide, and 18 feet deep and consisted of a balcony supported by twelve wooden columns. It contained Japanese carvings and a temple bell. This particular building was actually the second Japanese structure on this, the site of the Japan exhibit for the 1876 Centennial Exhibition.

Today, the Nio-mon has been replaced by yet another structure; a "shion," a replica of a 16th century upper class Japanese home. This was presented to the city in 1957 and had originally been on display at New York's Museum of Modern Art. Tea ceremonies and demonstrations of Japanese arts and crafts are given here regularly, and the gardens have been preserved.

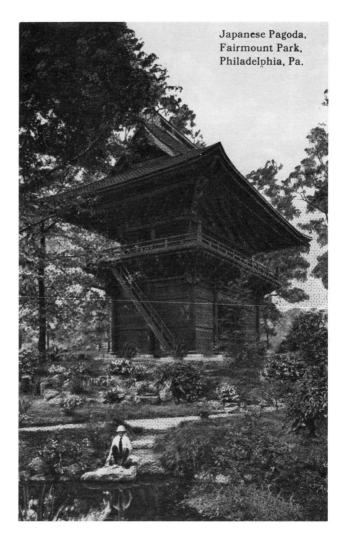

Japanese Pagoda,
Fairmount Park,
Philadelphia, Pa.

1907: This bucolic section of West River Drive is a part of Fairmount Park. The roadway has been paved and parking areas installed for those wishing to picnic or watch the river. In the 1950's, the Schuylkill Expressway was cut along the river to the right of this view; it is elevated and does not interfere greatly with the area's natural beauty. To the rear is the Park Trolley Bridge, closed in 1946.

PHILADELPHIA. River Drive and Bridle Path-Fairmount Park.

Dear Rhoda: May you have many more happy Birthdays. Your Friend Jennie Dawson.

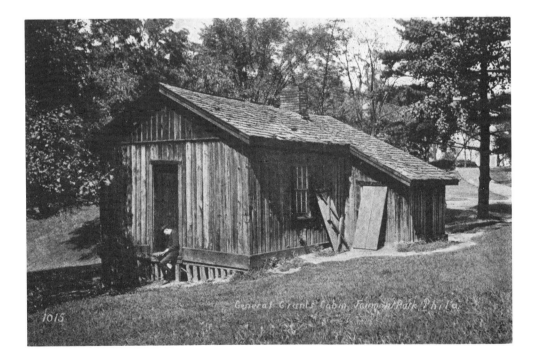

East River Drive, 1905: This log cabin was used by General Ulysses S. Grant at City Point, Virginia, during the siege of Richmond. It was moved to Fairmount Park in 1868 and set in a tranquil grove of oaks. In 1981, the building was given to the National Park Service and moved back to its original location at Appomatix Manor Plantation. The oak grove and the cabin's stone foundation are all that remain in the park.

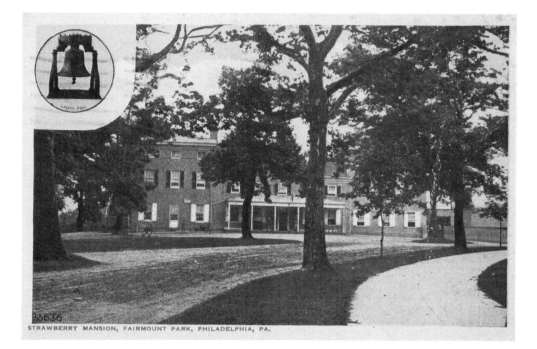

STRAWBERRY MANSION, FAIRMOUNT PARK, PHILADELPHIA, PA.

The stone central portion of this home was built in 1798 by Judge William Lewis, a friend of George Washington. The two, 3-story side wings were added in 1825 and 1828 by Judge Joseph Hemphill, a six-term Congressman. The grounds became a picnic spot in 1835 with the house serving as a restaurant. The area got its name because the first strawberries in the U. S. were supposedly grown here after 1820. Judge Hemphill was an owner of the Tucker porcelain firm, America's first successful high-quality porcelain manufacturer; the restored mansion, open to the public, includes a large collection of Tucker China.

Top of Strawberry Hill, Fairmount Park,
Philadelphia, Pa.

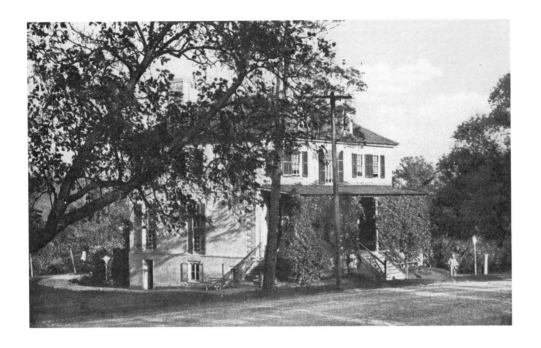

Lansdowne Drive, Fairmount Park, 1919: This home in the Federal style was built in 1797 by Samuel Breck, a judge, merchant, and member of Congress from 1823–1825. Mr. Breck moved to Philadelphia to relieve himself of Boston's higher taxes and built one of the first houses along the river that was lived in year-round.

Here we see the mansion before its 1926 restoration by the city's Junior League. At that time, the ivy-engulfed porch was removed to expose the original arched entranceway. The house is open to the public today.

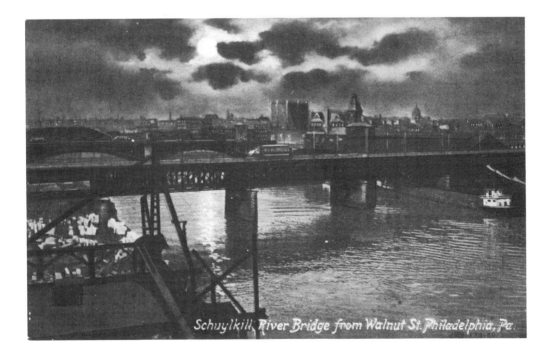

This view, from around 1905, shows a rather somber picture of the city's industrial center from Walnut Street. The bridges were then primarily for rail traffic; electric trolleys were the most common form of transportation. A large gas storage tank can be seen in the center of the card.

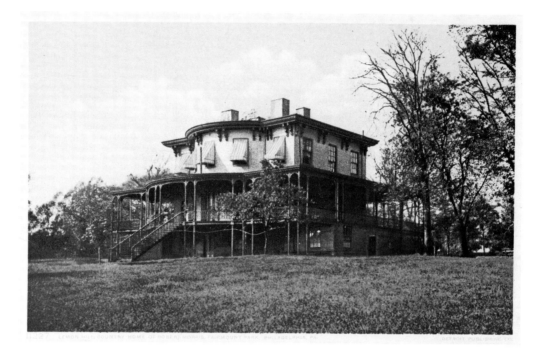

Henry Pratt bought "The Hills," Robert Morris' 350-acre farm overlooking the Schuylkill and in 1799, replaced the original 1770 home with this stone and stucco structure. During this period, the rich built summer homes along the river not only to vacation from the confining city, but to avoid occasional yellow fever epidemics.

Lemon Hill got its name from the lemon trees that Mr. Pratt grew in his garden (not an easy task in the local climate). This estate formed the basis of Fairmount Park when it was acquired by the city in 1855. For a number of years, the building was used as a beer hall and once was the site of a large observation tower from which the lower photograph was taken. Note the reservoir in center rear where the Philadelphia Museum of Art now stands. Lemon Hill was restored in the mid-1920's under the direction of Fiske Kimball, director of the Philadelphia Museum of Art, and it remains open to the public.

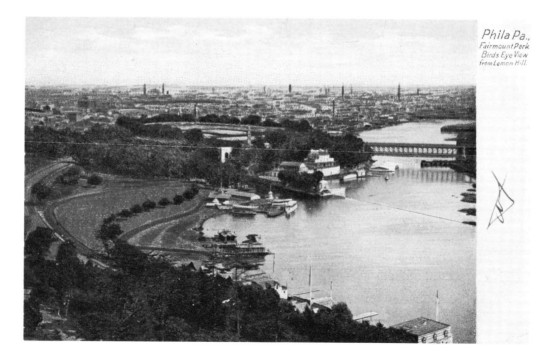

Phila Pa.,
Fairmount Park
Bird's Eye View
from Lemon Hill.

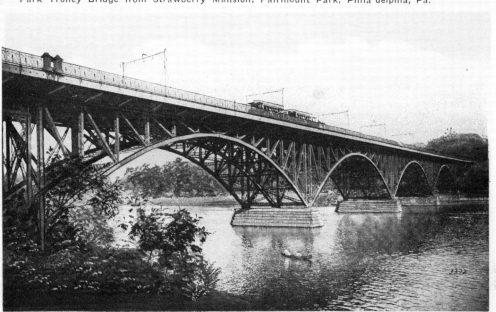

Park Trolley Bridge from Strawberry Mansion, Fairmount Park, Phila delphia, Pa.

By the time this card was sent (around 1915), Fairmount Park contained about 9½ miles of trolley lines, and this bridge brought pleasure-seekers and commuters across the Schuylkill River at Strawberry Mansion, one of a number of grand houses open to the public today. The trolley line closed in 1946 and motorcars now cross here. In recent years, busses have been built to resemble the old trolleys, and visitors may tour the park in them.

Forbidden Drive and Valley Green Road: At one time, numerous inns served travellers in this area—the heart of the Wissahickon Valley—but the Valley Green is the sole survivor. Built in the early 19th century, it is of stuccoed stone with newer rear additions. In winter, sleighing and ski parties gathered here while summer visitors fed the ducks in the stream. In the 1850's, a dancing pavilion was built behind the inn. In 1901, a women's patriotic group began to operate the inn, and its spirits were replaced with grape juice and tea.

Valley Green remains open today, hardly changed from this card and, with motor traffic forbidden on this road, seems quite far from any city.

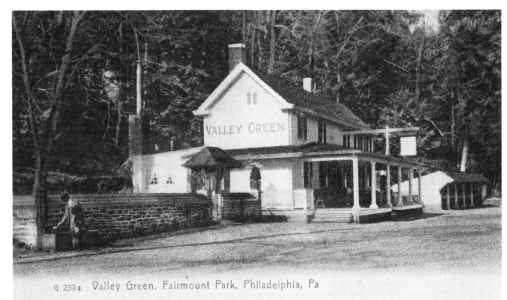

G 259a. Valley Green, Fairmount Park, Philadelphia, Pa

190?: Belmont Mansion was built in various stages beginning in 1742. The main part of the mansion was finished in 1755, and the Victorian porches and third story were added sometime before 1860.

This was originally the home of William Peters and his son Richard, noted public servants, who entertained here the notables of their day, including General Washington. Tourists were attracted by the beautiful view when the city acquired the property in 1867, and the mansion was operated as a restaurant until the 1960's.

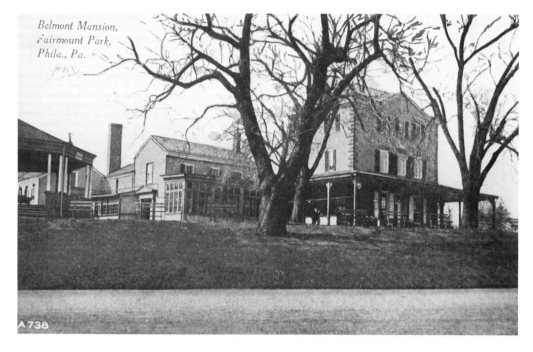

Belmont Mansion,
Fairmount Park,
Phila., Pa.

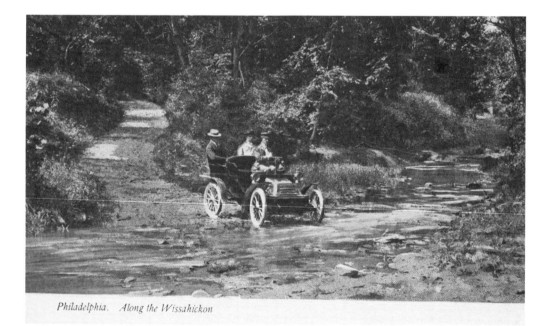

Philadelphia. Along the Wissahickon

Meaning "yellow stream" or "catfish stream" to the natives, Wissahickon Creek courses down the western section of the city right through the center of Fairmount Park. Its natural beauty has been preserved to the point that, in some sections, travellers would hardly know they were near the center of a large city. Automobiles are no longer permitted, but there are plenty of hiking, horse, and cycling trails in this area, including Wissahickin (or "Forbidden") Drive which runs 5½ miles along the creek (so-called because automobiles are forbidden). The area is also the site of wildlife preserves and trout fishing.

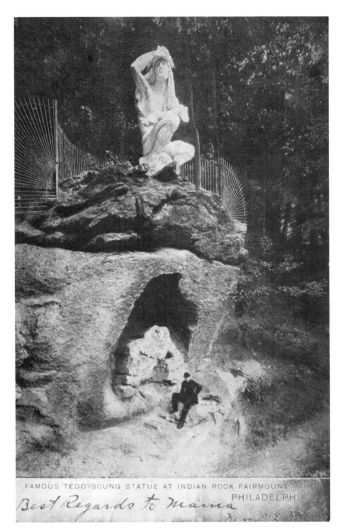

FAMOUS TEDDYSCUNG STATUE AT INDIAN ROCK FAIRMOUNT PARK
PHILADELPHIA

Best Regards to mama

Wissahickon Drive and Rex Avenue: A few blocks north of Valley Green Inn is Indian Rock, which was said to have been where the native Lenni Lenape people held council meetings. Atop the rock, which contains a small cave, is a stone carving of the tribe's pre-Revolutionary chief, Tedyuscung, which was erected in 1902 by Mr. and Mrs. C. W. Henry to replace the previous wooden figure, The 12-foot limestone sculpture was carved by John Massey Rhind.

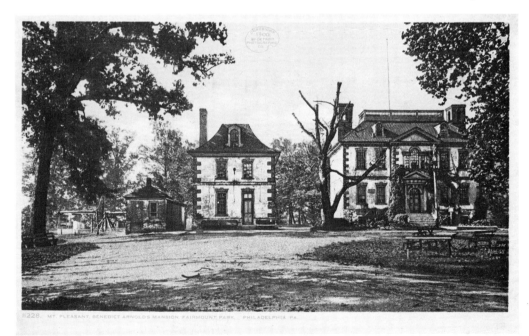

"Mount Pleasant," Mt. Pleasant Drive, 1900: Originally called "Clunie," this symmetrical Georgian mansion was built in 1761 by John MacPherson, a wealthy Scottish sea captain. The main house is flanked by twin side buildings (only one is visible here) in a style more common to Virginia than Philadelphia. In 1779, Benedict Arnold bought the property for his wife, Peggy Shippen, but never lived here due to his well-known legal problems.

Today, it is one of the many Fairmount Park houses open to the public, and includes demonstrations of colonial soap-making and weaving.

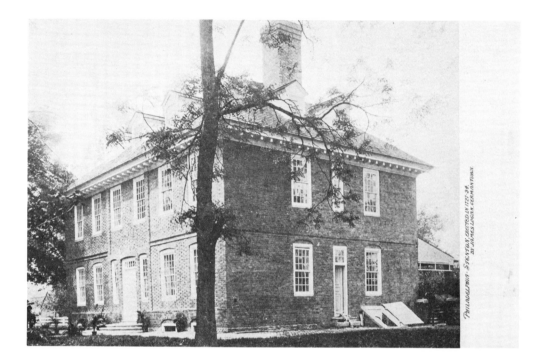

Courtland and 18th Streets: Stenton was built in 1728 for James Logan, William Penn's secretary and Chief Justice of the Pennsylvania Supreme Court. General Washington lived here shortly before the Battle of the Brandywine as did his rival, General Howe, during the Battle of Germantown. In its day, it housed the finest library in the city. The property was originally a 500-acre farm, but is now a more manageable five acres.

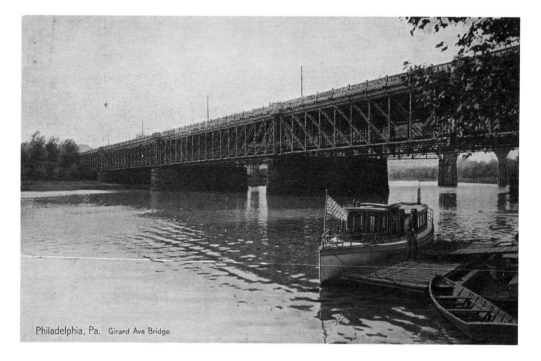

Philadelphia, Pa. Girard Ave Bridge.

The city expanded its infrastructure to handle the crowds expected for the Centennial Exposition and made good use of the facilities when the tourists left. The Girard Avenue Bridge was a good example. It was considered the widest bridge in the world (100 feet) when it opened in 1874. Henry and James Sims were the architects. The wrought iron, quadrilateral, Pratt deck truss was erected by the Phoenixville Iron Company. Over 800 bronze panels depicting birds and foliage were set into the outer balustrade.

The bridge was considered quite a marvel, judging by the number of postcards showing it being washed by starlit skies and lapped by the tranquil Schuylkill River. Romance bowed to practicality, however, when the old bridge was replaced in 1971. Its only remnants are parts of the iron railing in the Smithsonian Institution and a few decorative panels leading up to the new structure.

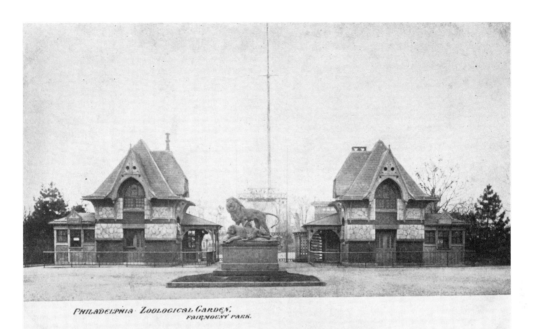

PHILADELPHIA ZOOLOGICAL GARDEN.
FAIRMOUNT PARK.

The Philadelphia Zoo, as it is best known, was established in 1859, making it the first of its kind in the country. It is located in the southern part of Fairmount Park along the Schuylkill River near Memorial Hall and the Centennial grounds.

In its early years, the zoo established research and breeding programs that made it more than the usual menagerie of the period. In 1901, for example, the Penrose Research Laboratory was the first of its type set up in a zoological garden.

Architecturally, the zoo has some fascinating offerings. The two granite and brick entrance pavilions (above) still welcome visitors to the zoo. They were designed by Furness and Hewitt in 1875. Theophilus Parsons Chandler, Jr., designed the bear pits (not shown here) in 1874. Wilhelm Friedrich's 1873 sculpture depicts a lion watching over his dying mate. A monorail ride has replaced the goat carriages (below), but a special section has been set aside for children.

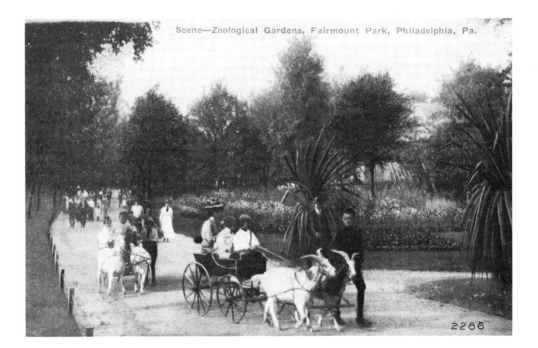

Scene—Zoological Gardens, Fairmount Park, Philadelphia, Pa.

2288

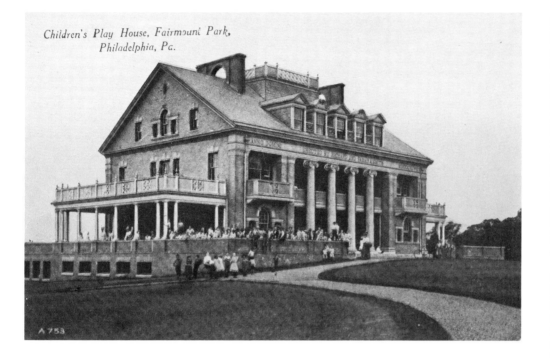

Children's Play House, Fairmount Park, Philadelphia, Pa.

Fountain Green Drive, 1913: In addition to an impressive monument (see "Smith Memorial" on page 58), Richard Smith left the city $50,000 for what nowadays might be called day care. When his wife Sarah died in 1895, she left additional funds for the same purpose, and this Children's Play House opened on July 23, 1899.

It was almost a self-contained city for youngsters and included reading and reception rooms, games, a music room, dispensary, and large aquarium in the basement. Outside, there were six acres of playground equipment, a junior merry-go-round, a "sand pavilion," lawn tennis, basketball, and a bike course. Anyone under the age of ten was admitted. By 1921, over 2,200,00 children played here with no serious injuries.

Similar "Children's Villages" were set up in Northern Liberties, Stanfield House, and Ferry Road. At these locations, children were assigned rolls as housekeepers, store owners, business people, etc. They were given $2.50 in play money and, for a day, actually ran their own make-believe towns.

The Children's Play House is still open today.

1905: Cobbs Creek Park was acquired by the city in 1910 and, at 621 acres, is the largest park area in West Philadelphia. An additional 154 acres lies across this creek in Delaware County. A winter view of Cobbs Creek Falls, a tranquil six-foot waterfall, is seen in this postcard. Among other diversions, the park includes riding trails, golfing, ice skating, and camping.

In 1643, Pennsylvania's first grist mill was built in this area.

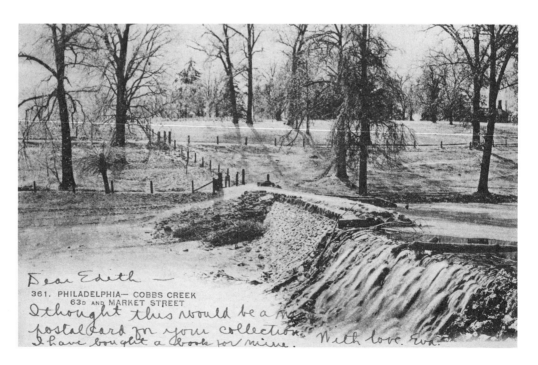

Dear Edith —
361. PHILADELPHIA— COBBS CREEK
63D AND MARKET STREET
I thought this would be a nice postal card for your collection. I have bought a book for mine. With love, Eva.

Though not a part of the city, Willow Grove Park, along with Atlantic City, was a highly popular destination for fun-seeking Philadelphians. In fact, these turn-of-the-century cards are usually captioned as being of Philadelphia. Willow Grove Park was established and run by the Philadelphia Rapid Transit Company to lure people into using their line on weekends and holidays. It was one of the

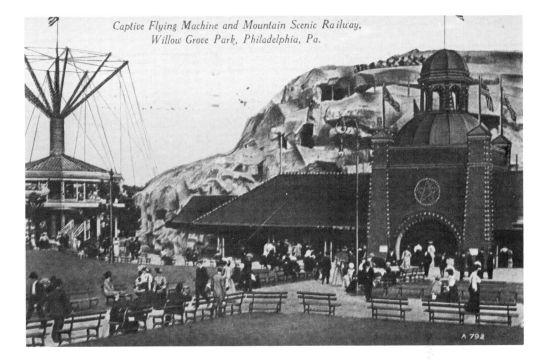

Captive Flying Machine and Mountain Scenic Railway, Willow Grove Park, Philadelphia, Pa.

largest and most popular amusement parks in the country.

Here, we see the lake and refreshment stands. The sender of this card says: "This size crowd is often seen on a Saturday afternoon and all day Sunday. They have the very best of music that can be obtained. Sousa's band is often here two weeks at a time." In fact, John Philip Sousa was one of the main attractions at the park every year.

Willow Grove park fell onto hard times after the Second World War and, after various ownership changes, was demolished and replaced by a shopping mall in the early 1980's.

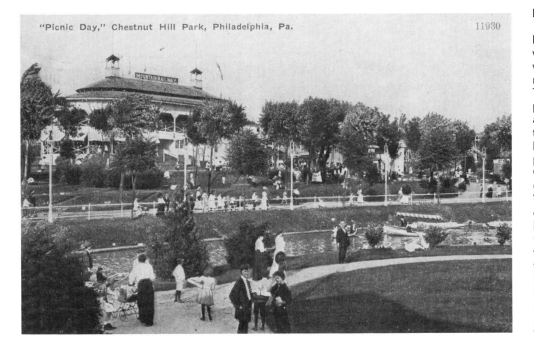

"Picnic Day," Chestnut Hill Park, Philadelphia, Pa. 11930

Bethlehem Pike, 1911: The early public transit systems were privately owned with right-of-ways rented from the city. To increase their profits on weekends and holidays, the trolley companies built amusement parks in the suburbs. Chestnut Hill Park (also called "The White City" because of the color of its buildings) was unique because it was seviced by *two* trolley firms—the PRT (Phildelphia Rapid Transit) and Lehigh Valley Transit (which went all the way to Allentown). A ride to the park from anywhere in the city cost five cents. Attractions included a band stand that, when the park first opened in 1898, boasted Kalitz's "52 Famous Musicians" in the afternoons and evenings. The Mountain Railway (shown here) was struck by lightning and burned in 1899—one year after it opened—and burned again in 1907.

The park's well-to-do Chestnut Hill neighbors didn't find the park too amusing, however, saying it depreciated land values and "lowered the tone of the entire suburb." They proved themselves serious when they bought the park in 1912 and had it torn down.

In 1924, Erdenheim High School was built on this site east of Bethlehem Pike at Hillcrest Avenue. This was later replaced by Hillcrest Junior High. Chestnut Park—greenery, but no rides—still hosts picnics here today. The only remnant of the White City is Hillcrest Lake where fun-seekers once drifted in their gondolas.

Monuments

Justus Strawbridge, co-founder of the Strawbridge &
Clothier Department Store, was talking with William Pep-
per, former provost of the University of Pennsylvania,
when they realized that the city's favorite son, Ben
Franklin, had not one major statue in his honor. Discov-
ering an outlet for his philanthropy, Strawbridge con-
tacted local sculptor John J. Boyle and commissioned a
large bronze statue of Dr. Franklin which, it was agreed,
would be set in front of the Chestnut Street Post Office.
In June, 1899, the likeness was unveiled before the
invited representatives of six local institutions that Frank-
lin had founded. Forty years later, when the new Post
Office was built, the monument was moved to the Uni-
versity of Pennsylvania Campus where it remains today.

501 PHILADELPHIA—BENJAMIN FRANKLIN STATUE.

BUSSE ART CARD CO., PHILADELPHIA, PA.

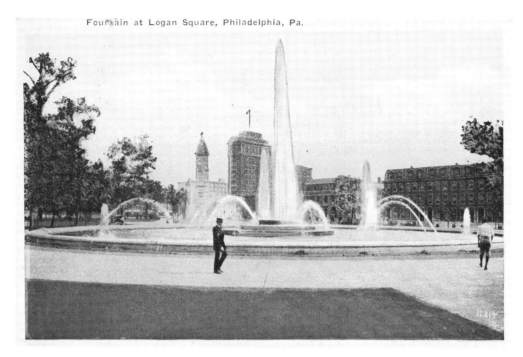

Fountain at Logan Square, Philadelphia, Pa.

Logan Circle and Swann Memorial Fountain, 1923: This is Northeast Square, one of the five squares set out by William Penn in his original plans. It was renamed for James Logan (see "Stenton Mansion" page 50), Mr. Penn's financially successful secretary (and, incidentally, the inventor of the Conestoga wagon and the storm window).

Dr. Wilson Carey Swann founded the Philadelphia Fountain Society to provide watering places for horses, and his wife bequeathed the funds to build this fountain in his memory. The design was conceived by architect Wilson Eyre, and the sculptor was Alexander Sterling Calder, the son of Alexander Milne Calder, who created City Hall's statuary.

Above, the fountain is seen in operation before the statues were in place; below is the completed fountain, the most impressive and best-loved in the city. Three large figures represent local bodies of water: the Delaware River, the Schuylkill River, and the Wissahickon Creek. Not visible in the lower card are frogs and turtles that squirt water toward the fountain's center. After some years of plumbing disorder, the fountain was dismantled in 1989 for complete restoration.

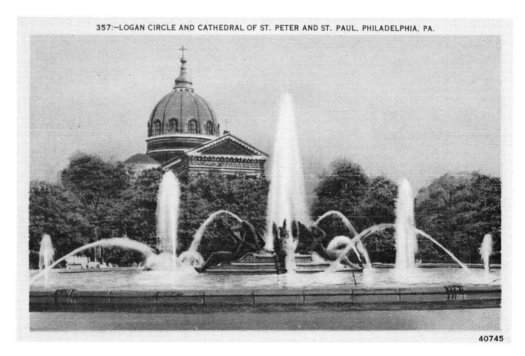

357:—LOGAN CIRCLE AND CATHEDRAL OF ST. PETER AND ST. PAUL, PHILADELPHIA, PA.

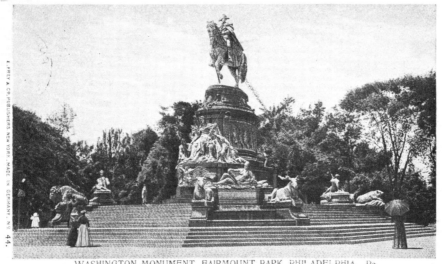

WASHINGTON MONUMENT, FAIRMOUNT PARK, PHILADELPHIA. Pa.

Philadelphia Pa sept 20 1/00
Dear Miss Wells this is much the finest statue in this City
Sincerely New Cole

1905: There had been talk of a great monument to General Washington since about 1810, but it was not until 1897 that this equestrian statue sponsored by the Society of the Cincinnati of Pennsylvania was unveiled. The society members, descendants of Washington's officers, hired the German sculptor Rudolf Siemering for $250,000.

The General is between four fountains and animals that symbolize the Delaware, Hudson, Potomac, and Mississippi Rivers. The thirteen steps represent the states. Elsewhere is America receiving trophies from her victorious sons, a group representing the evils of slavery, and reliefs depicting the settling of the West and the American Army. It was rumored (probably incorrectly) that the figure of Washington was originally intended to be Frederick the Great and that only the hat and medals were changed by the sculptor.

The monument was moved from this site (the Green Street entrance to Fairmount Park) about two blocks to its present location in front of the Art Museum in 1926 at a cost of $80,000.

The writer of this card states: "This is much the finest statue in the city."

East River and Lemon Hill Drives: This monument, according to its creator, Randoph Rogers, shows "Mr. Lincoln in a sitting posture, holding in one hand the Emancipation Proclamation, and a pen in the other, his eyes toward heaven, asking the Almighty his approval for the act. It was the great event of his life." It was dedicated in 1871. Mr. Lincoln sits on a granite pedestal decorated with four eagles, Philadelphia's coat of arms, and garlands. It was a gift from the Lincoln Monument Association and reads: "To Abraham Lincoln from a Grateful People."

LINCOLN STATUE, FAIRMOUNT PARK. PHILADELPHIA, PA.

Philadelphia, Pa. Statue, Gen. Grant, Fairmount Park.

(Right) Ulysses S. Grant, President during the Centennial Exposition and visitor to Philadelphia numerous times, was immortalized in 1897 by Daniel Chester French and Edward C. Potter in what many deem the finest equestrian statue in the city. It depicts Grant in his glory days as General of the Union forces. Since Grant had died seven years earlier, French used photographs to achieve the likeness. The horse, slightly reined in, supports the pensive General. According to Mr. French, the intent was to show the "latent force of the man."

GARFIELD MONUMENT, FAIRMOUNT PK., PHILA.

(Left) The monument of James A. Garfield was completed in 1897 by Augustus Saint-Gaudens. It is located on Kelly Drive below the Girard Avenue Bridge quite near the Grant statue. Saint-Gaudens modelled the bust after the martyred President's death mask. The front of the statue represents the republic holding an inscribed shield bearing an American eagle and Garfield's dates in office. The pedestal was designed by Stanford White, a frequent collaborator with Saint-Gaudens.

1908: The Fair-
mount Park Art
Association was
organized in 1872
to "promote and
foster the beautiful
in the City of Phila-
delphia." This
group was
entrusted with the
task of erecting a
Civil War monu-
ment near Memo-
rial Hall to be paid
for by Richard
Smith, a successful
typefounder. The
Smith Memorial
contains works by
some of the great
sculptors of the
period, and took fif-
teen years to com-
plete (it was begun
in 1897). Its archi-
tects were John T.
and James H. Windrim.

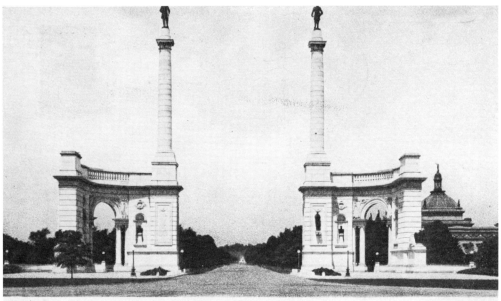

183. Smith Memorial, Fairmount Park, Philadelphia, Pa.

Atop the huge columns are bronze statues of Gen-
erals Meade (left) and Reynolds. Other statues run the
gamut from military leaders to the memorial's architect
and the executor of Mr. Smith's will. To the right of the
opening is a statue of Mr. Smith himself. The dome in
the background belongs to Memorial Hall.

East Columbia Avenue and Beach Street: Tradition has
it that, in 1683, William Penn signed a treaty with the
local Indian tribes under an old elm near the Indian vil-
lage of Shakamaxon. Although historians have their
doubts about the event, Penn did purchase rather than
forcibly take property from the locals—a liberal policy
for the time and consistent with Penn's Quaker princi-
ples. The Pennsylvania Historical Society has a wam-
pum belt donated by Penn's descendants said to have
been exchanged at this site. It shows a white man
shaking hands with an Indian. The marker in what is
now Penn Treaty Park was placed there by the Penn
society in 1827 and says: "A TREATY GROUND of
WILLIAM PENN and the INDIAN NATIVES 1682.
Unbroken Faith."

PENN TREATY MONUMENT, PHILADELPHIA, PA.

The Centennial and Sesquicentennial

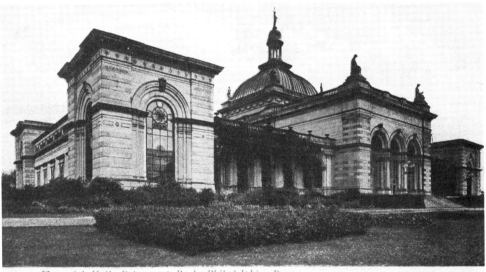

2373—Memorial Hall, Fairmount Park, Philadelphia, Pa.

1906: Memorial Hall is the only major building remaining from the 1876 Centennial Exhibition. Designed by Hermann J. Schwarzmann in the Beaux-Arts style, it was an important inspiration for later designers of civic and exposition structures. During the Centennial, it was filled with romantic and allegorical sculpture and paintings of the late 19th century.

It was intended to be a permanent structure and served as Philadelphia's Museum of Art from 1876 to 1928, but after the new museum was built on the Parkway, Memorial Hall seemed to be a building without a purpose. It has been fairly well maintained over the years; today, it is the headquarters of the Fairmount Park Commission, park police headquarters, and a recreational center. The basement holds a 20-by-40-foot scale model of the Centennial Exhibition and its 249 buildings.

In the view above, the large glass and iron dome that illuminates the interior is seen plus the two large zinc statues atop the main entrance representing science and art. Columbia stands high above the dome surrounded by four more statues representing Industry, Commerce, Agriculture, and Mining (all by A. J. M. Muller of Germany).

59

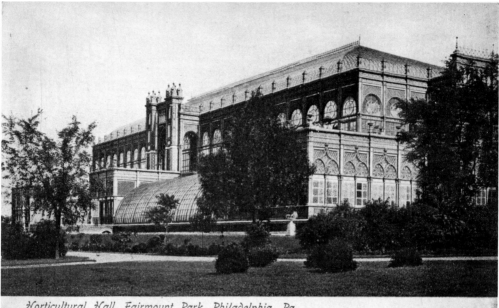

Horticultural Hall, Fairmount Park, Philadelphia, Pa.

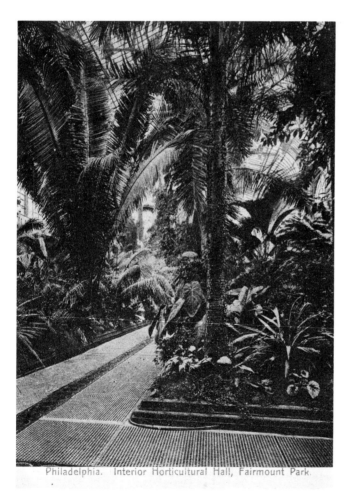

Philadelphia. Interior Horticultural Hall, Fairmount Park.

1912: Built for the 1876 Centennial Exhibition, this greenhouse of glass and iron also designed by Hermann J. Schwartzmann followed the design of London's 1850 Crystal Palace. The German-born Schwartzmann was an engineer for the Fairmount Park Commission who had no architectural training and had never designed a building. Nevertheless, Horticultural Hall survived well into the twentieth century.

Three hundred and eighty feet long and costing $370,000, it was the successor to a more modest conservatory next to the Academy of Music (see p. 68). The ironwork of Horticultural Hall was colorfully painted in red, green, and yellow. Inside were 32 varieties of palms, a cactus house, aisles of chrysanthemums, vines, and exotic trees. A sunken garden lay along Belmont Avenue to the main entrance along with reflecting pools and a lily pond.

Due to the exorbitant cost of heating and maintenance coupled with some hurricane damage, this great monument was demolished in the mid-1950's. A facsimile of its sunken garden was recently opened at the Smithsonian Institution in Washington, D. C.

SESQUI-CENTENNIAL INTERNATIONAL EXPOSITION, PHILADELPHIA, PA.

1926: Philadelphia celebrated the Nation's 150th anniversary with a 670-acre World's Fair at League Island Park in South Philadelphia. The site, owned by contractor and political boss William S. Vare and a group of speculators, was largely swamp land unsuitable for building. The city paid the owners for the right to fill it in plus a rental fee. Meanwhile, other speculators found themselves in possession of over-priced land miles from the site chosen.

After much tribulation, the Fair opened on schedule (May 31, 1926), although by July 5th, 10% of the exhibits still had not been completed. Municipal (now JFK) Stadium was erected for the Exhibition and was the scene of the famous September 1926 Dempsey-Tunney fight. Almost every state in the Union and many foreign countries had buildings or displays. There were exhibits of electric refrigerators and talking films. The 130-acre amusement center was called the "Gladway," and included lakes and lagoons with Venetian gondolas and fifty motor launches. Solomon's Temple was reproduced on 23 acres. The Navy Yard, with its large aircraft factory and airdrome, was the site of many air displays and races. An eighty-foot tall Liberty Bell with 26,000 15-watt light bulbs greeted guests at the main entrance.

Unfortunately, the fair was not a financial success (it rained 107 of the 184 days the Exposition was open), and the city had to bail it out of a $5,000,000 debt. The filled-in land was later used to construct the city's complex of sports areas, the Spectrum, and Veteran's Stadium. The old Municipal Stadium remains, although its fate is in doubt.

BATTLE OF
TTLE OF
TTYSBURG
HRILLS
WITH THE
SH-ROAR
RUMBLE
BATTLE

SESQUI-CENTENNIAL INTERNATIONAL EXPOSITION, PHILADELPHIA, PA.

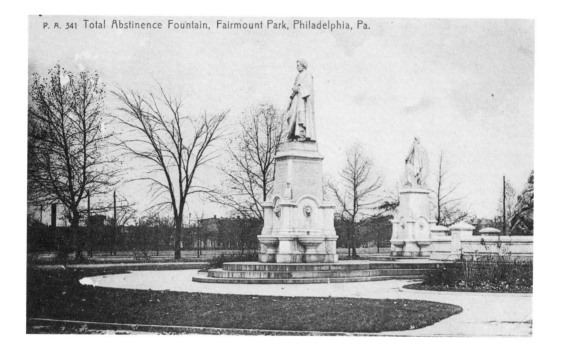

P. A. 341 Total Abstinence Fountain, Fairmount Park, Philadelphia, Pa.

1902: This monument was installed for the Centennial Exposition in 1876 by the Catholic Total Abstinence Union of America and was then known as the Roman Catholic Centennial Fountain. This card shows only a partial view of what is actually a huge drinking fountain. One could climb the three steps to each of four statues—Charles Carroll, Father Mathew, Archbishop Carroll, and Commodore John Barry (two of the statues are shown)—and sip from basins filled by lion head spigots. The central figure is Moses atop a huge rock (just visible on the right) holding a staff. He has just struck the rock, and a stream of water is spewing out.

The $50,000 sculpture by Philadelphian Herman Kirn still stands as abstinent as ever but without the drinking fountains.

Libraries, Museums, and Theatres

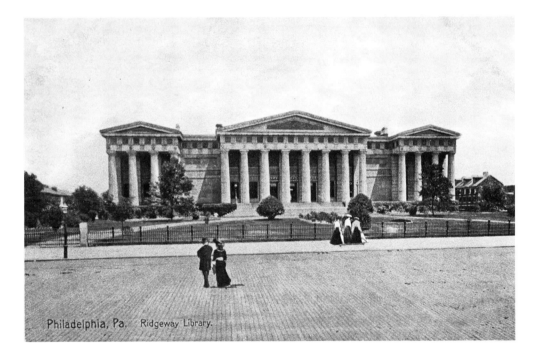

Philadelphia, Pa. Ridgeway Library.

900 South Broad Street, 1908: Dr. James Rush (eccentric son of Benjamin Rush, the pioneering physician) bequeathed $1,000,000 to the Library Company of Philadelphia for the erection of this library on the condition that it be built on the site of his choice. The site turned out to be rather far away from the Company's membership, but the money was accepted and the library opened in 1878. It was named in honor of Phoebe Ann Ridgway Rush, the doctor's wife from whom he inherited his fortune. (Note incorrect spelling on postcard.)

Addison Hutton was the architect of what has been considered the last Greek Revival building in the U. S. Its 220-foot width is of granite-faced brick. It was constructed with a clever system of skylights to ease eye strain.

Unfortunately, the library was never accepted by the public and was vacated in 1966. It has been a recreation center since 1973.

Broad Street and Girard Avenue, 1906: Peter Arrell Brown Widener began his career as an assistant in his brother's butcher shop and climaxed it by owning all of the city's street railways. By the time he donated his home for use as a branch of the Free Library, he was probably its wealthiest citizen. This mansion was designed for Widener (the card spelling is incorrect) in 1887 by Willis G. Hale and decorated by George Herzog, who also decorated the Union League. It changed from a mansion to the J. Josephine Widener Memorial Library in 1900, still retaining its gold-plated bathroom fixtures and Mr. Widener's collection of incunabula. It ceased to be a library in 1946 and, in 1970, became home to The Council of Black Clergy's Institute for Black Ministries. It was destroyed by fire in 1981.

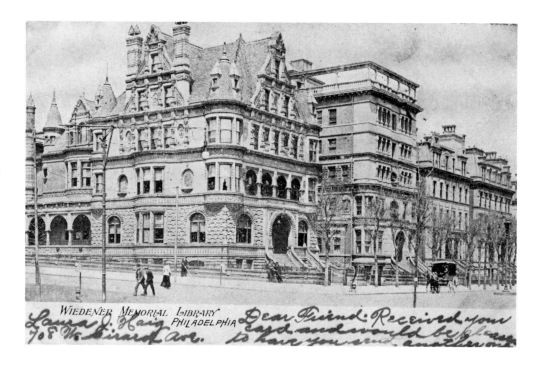

345:—Rodin Museum, Parkway and 22nd St., Philadelphia, Pa.

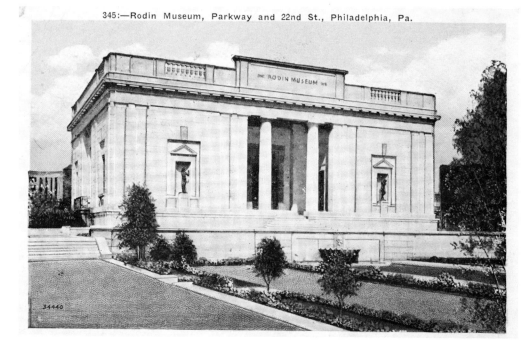

22nd Street and Benjamin Franklin Parkway, 1929: In 1924, Jules Mastbaum, a successful Philadelphia movie theatre owner, returned from France with an Auguste Rodin bronze. Mastbaum's interest in the French artist grew along with his fortune, and this small museum was his posthumous gift to the city in 1929. It is a copy of the Musée Rodin in Meudan, France, and was designed by Paul Philippe Cret and Jaques Greber, the same two men who planned the Benjamin Franklin Parkway. Inside is Mastbaum's collection of Rodin's sculpture and drawings—the largest outside of France. In front of the museum is a bronze replica of the sculptor's most famous work, "The Thinker."

Pennsylvania Museum of Art, 26th and Benjamin Franklin Parkway, 1928: Construction began in 1919 on what was to become one of the world's great art museums. Designed by Zantzinger & Borie and Horace Trumbauer in 20th century eclectic Neoclassical style, it overlooks the Benjamin Franklin Parkway from its northwest end like the ancient Greek temple it copies.

The spot was formerly occupied by a city reservoir. In fine Philadelphia tradition, the building's cost rose from

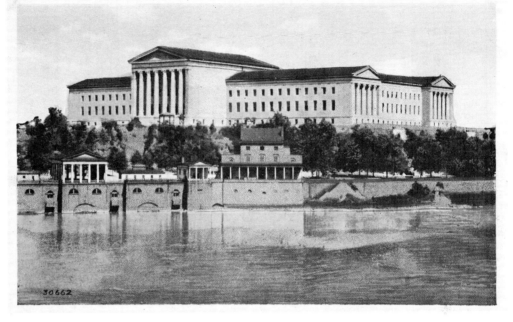

87:—Art Gallery from Schuylkill River, Fairmount Park, Philadelphia, Pa.

$5,000,000 to $25,000,000 by the time it opened in 1928 (although it was not entirely completed until 1937). There was some controversy about the classical design, but Philadelphians have come to respect this imposing building, which was renamed the Philadelphia Museum of Art in 1938.

In the foreground of the card are the Fairmount Waterworks (see p. 39 for a "before" view).

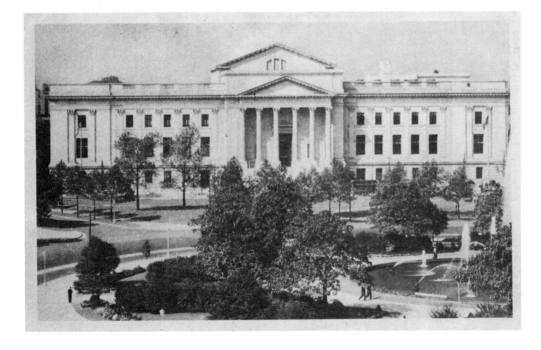

Franklin Institute, 20th and Benjamin Franklin Parkway, 1934: The Franklin Institute was founded in 1824 by Samuel Vaughn Merrick and named for (of course) Benjamin Franklin. It promoted the study of mechanical arts and applied science. This building, begun in 1930 and opened in 1934, was designed by John T. Windrim after the Deutsches Museum in Munich. It remains open today facing Logan Circle's Swann Memorial Fountain and is probably every child's favorite Philadelphia museum.

Inside is an impressive thirty-ton marble statue of Franklin designed much like that of Lincoln in his Memorial in Washington. Visitors can see paper being made, coins struck, and sparks flying. They can walk on board a 350-ton Baldwin locomotive that really moves. Visitors can also push buttons to animate numerous machines, walk inside a giant heart and . . . well, you get the idea. The building also contains the Fels Planetarium (the second such building in this country), which projects heavenly views on a metal dome 68 feet wide. In 1990, a large new wing was opened.

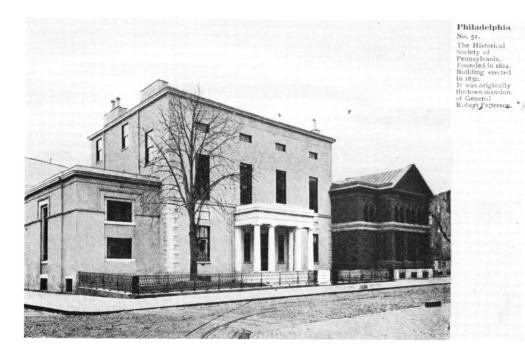

Philadelphia
No. 51.
The Historical
Society of
Pennsylvania.
Founded in 1824.
Building erected
in 1832.
It was originally
the town mansion
of General
Robert Patterson.

1300 Locust Street, 1900?: The Historical Society was founded in 1824 and met at various locations until the acquisition of General Patterson's home at 13th and Locust in 1882. (In 1861, the 70-year old General led the first group of Pennsylvania soldiers to Washington to fight in the Civil War.) Eventually, this building was demolished, and the present headquarters of the society was opened in 1910. One aspect of the old structure remains, however: the colonnaded entranceway.

The Society remains active today with its exhibition gallery open to the public along with a 500,000-volume library, 14,000,000 maps, prints, photographs, and other archival items including the Penn and Logan family records and over 6,000 items from these families for study and display.

Broad and Cherry Streets, 1907: In 1791, the artist Charles Wilson Peale circulated a petition calling for the establishment of a training school for young artists, but it was not until 1805 that a group met at Independence Hall to establish the Pennsylvania Academy of Fine Arts, the first such institution in the young United States. The Academy moved from Chestnut near 10th to this fanciful building designed by Frank Furness in 1876.

The inside, it should be mentioned, is as unique as the outside. Furness used heavy ornamental iron pillars, a system of skylights, and colorful stencils and tiles in a design centered on a grand staircase. The classical statue above the entrance was removed around 1935; and the building altered, eventually deteriorating over the years. However, it was restored to its original appearance in 1976.

The Academy still trains students of the fine arts, and also houses an important collection of American paintings and sculpture.

12th and Sansom Streets: The Academy is one of the city's pioneering scientific institutions, organized in 1812 by John Speakman, a druggist, and a group of friends interested in nature. The group sponsored expeditions as early as an 1819 trek to the Rocky Mountains and the Wilke's Antarctic expedition in 1838. The best-known exploration sponsored by the Academy was that of Admiral Robert E. Peary to the North Pole.

Academy of Natural Science, Philadelphia, Pa.

In 1826, the Swedenborgian Church at 12th and Sansom (shown here) was purchased to house the Academy's growing collections; in 1876, they moved to their present location at 19th Street and Benjamin Franklin Parkway. Today, visitors are attracted by the insects, birds, dinosaurs, gemstones, and other natural specimens collected over almost 200 years.

Commercial Museum, Philadelphia, Pa.

34th Street and Vintage Avenue: The Philadelphia Commercial Museum was organized by 1894 by Dr. David P. Wilson to promote foreign trade with the city of Philadelphia. Dr. Wilson was inspired by the 1893 Columbian Exposition in Chicago and the void left by the 1876 Centennial Exposition that very successfully promoted foreign trade. The original plans called for a complex of archaeological, ethnological, and general museums, but the commercial aspect was eventually favored.

The operation was divided into three areas: (1) the Museum, which exhibited foreign products (such as Mexican fibers, Chilean hides and wool, and Brazilian woods) and could give potential buyers the cost and source of all of the items on display as well as alert foreign suppliers of American needs; (2) the Information Section, which subscribed to over 1200 trade journals (translated by the staff of 150) and notified appropriate American manufacturers when potential markets were discovered (two thousand such notices were sent each month); and (3) the Education Section, which employed two full-time teachers to instruct visiting school children.

The building still stands as the Museum of the Philadelphia Civic Center. Although it is now primarily city offices, occasional exhibits are presented.

Architectural Record lauded Frank Miles Day's new buiding next to the Academy of Music: ". . . the best thing Mr. Day has done. Nothing appears that does not justify itself by its inherent beauty. One has the same impulse to sit down before it with sketchbook and pencil that manifests itself in Italy."

The Hall's warm gold, yellow, and red exterior and marble-pillared interior no doubt inspired many a romantic. But the realists prevailed when, in 1876, a larger Horticultural Hall was built on the grounds of the Centennial Exposition, and this building was eventually demolished. This spot is now occupied by the Shubert Theatre.

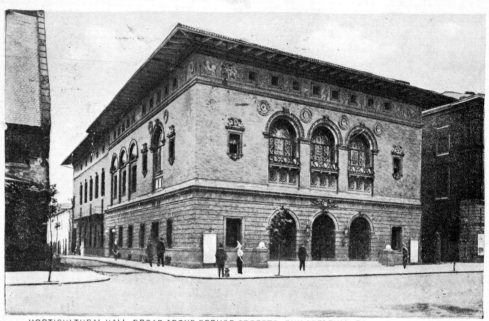

HORTICULTURAL HALL, BROAD ABOVE SPRUCE STREETS, PHILADELPHIA, PA.

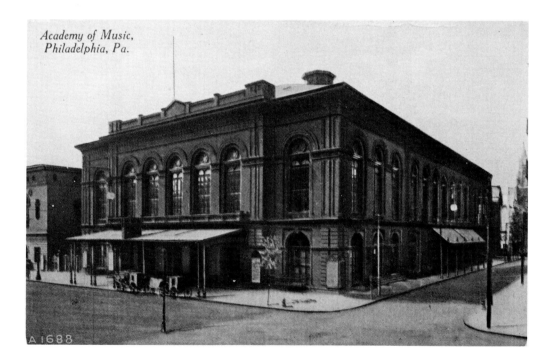

Academy of Music, Philadelphia, Pa.

South Broad and Locust Streets: Napoleon LeBrun and G. Runge won an 1854 competition to design the American Academy of Music with plans calling for a marble-covered Italianate exterior based on Rome's La Scala Opera House. Budgetary considerations changed the marble to brick and sandstone, but the sumptuous auditorium's statuary, baroque ornamentation, and huge crystal chandelier (from New York's Crystal Palace) more than made amends for the plain exterior.

Since its first performance of *Il Trovatore* in 1857, the Academy has presented everyone and everything from Caruso and Kreisler to the Hagenbeck-Wallace Circus and indoor football. The Philadelphia Orchestra has played here since 1900. Now completely restored, this is the oldest active musical auditorium in the country.

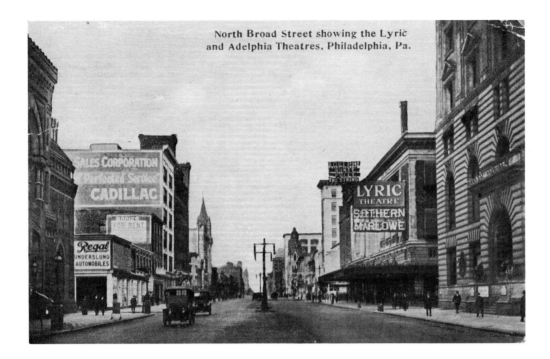

North Broad Street showing the Lyric
and Adelphia Theatres, Philadelphia, Pa.

Above, Cherry Street, 1913: The Lyric and Adelphi Theatres shared a common facade and were both operated by the Shubert organization. The Lyric opened in 1905 and featured mostly musical comedy. It could seat 1,629 patrons in a classically inspired green and white setting, and boasted a solid concrete and iron fire wall mounted on steel tracks that would seal off the stage if the temperature exceeded 140 degrees. The site of both theatres was owned by the Wanamaker estate; the second box on the lower floor, right (private entrance), was always reserved for the Wanamaker family. The Lyric's checkered history caused *The Bulletin* to call it "the most closed showhouse in town."

The Adelphi Theatre, like the Lyric, was designed by James H. Windrim. It opened in 1907 with Joe Weber in "Hip Hip Hooray" and could seat 1,234 patrons in its "late Italian Renaissance" interior decorated in simple earth tones of red, gold, blue, and brown. The gentlemen's smoking room was in the English Renaissance style. The Adelphi was somewhat narrower than the Lyric and featured mostly dramatic performances. The Shuberts gave up their leases in 1930, and business was sketchy after that. The concrete curtain finally dropped in 1937 when both theatres were demolished.

On the far left of this card is the Pennsylvania Academy of Fine Arts (see page 66).

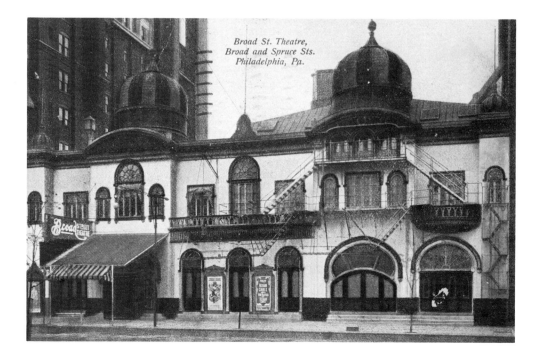

Broad St. Theatre,
Broad and Spruce Sts.
Philadelphia, Pa.

1909: For many years, this theatre was the unlikely king of the city's legitimate theatres and was called "Kiralfy's Alhambra Palace" when it was built as a temporary attraction for Centennial tourists in 1876. It originally featured spectaculars such as Jules Verne's *Around the World in 80 Days*; by the 1890's, it offered straight drama. Under various owners and names ("Lyceum," "Haverly's," "McCaull's Opera House"), it did a steady business, stealing elite theatre-goers from the older Walnut and Arch Street Theatres.

The building was a colorful blend of Moorish art with a heavy dose of showmanship. Edwin Booth played here, as did Sarah Bernhardt (who demanded her $99.00 pay in cash before each curtain). Gilbert and Sullivan's *H. M. S. Pinafore* had its American premier here in 1878.

An important piece of American theatre history ended when the Broad Street closed in 1936 and was demolished for a parking lot in 1937. Said *The Bulletin*: "With virtually nothing to recommend it, architecturally or in appointments, the Broad drew the most elegant of clienteles . . . the role it played cannot be ignored."

Just north of the building was a spacious beer garden used for concerts and promenades. This later became the Hotel Walton, visible on the left in this card.

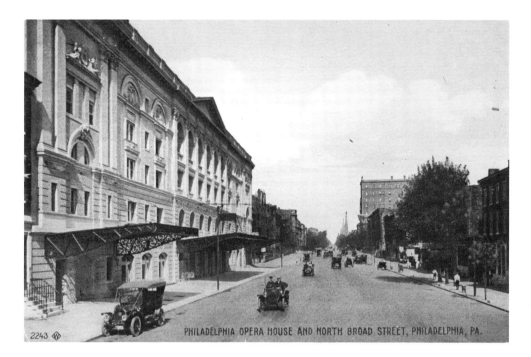

PHILADELPHIA OPERA HOUSE AND NORTH BROAD STREET, PHILADELPHIA, PA.

1910: At the turn of the century, Oscar Hammerstein I (the famous lyricist's father) declared "war" on the Metropolitan Opera Company in New York and began presenting lavish productions at his own Manhattan Opera House. He extended his base to Philadelphia and produced four shows a week here while the Met had but one (at the Academy of Music). Oscar's son Arthur supervised construction of the Philadelphia Opera House on this site of the old Harrah Mansion.

The monumental structure was completed in five months and seventeen days, costing $1.2 million. "Hammerstein's Opera House" or the "Philadelphia Opera House" was designed by William H. McElfatrick. It seated 4,100 patrons, and had a stage 116 feet wide and 90 feet high. The auditorium was carpeted in dark red with four immense Pavanazza marble staircases leading from the grand foyer. The balcony (the largest in the world) overlooked a buff, green, red, and gold ceiling. The 52 boxes, which cost $2,000 for the season (later $13,000), were filled on opening night—November 17, 1908—when Maria Labia sang *Carmen* with a cast of 700. The house had an 80-piece orchestra, a 50-member ballet corps, plus a chorus. Rehearsals were held with the New York Company so that the stars could play comfortably in either house. A conservatory of music was also planned.

Alas, after two years, mounting debts forced Mr. Hammerstein to sell out to his arch-rivals; his theatre was then known as the Metropolitan Opera House. The Met, too, failed to support their own Philadelphia house and in 1920, they returned to the Academy of Music. The Opera House was sold at auction for $665,000, and then used for vaudeville and some opera performances. Over the years, the stately old theatre hosted numerous owners and their basketball games, wrestling matches, roller derbies, and movies. Despite its rocky history, the Met still stands—somewhat the worse for wear—serving as a church. Until recently, the Philadelphia Orchestra recorded here because of the house's fine acoustics.

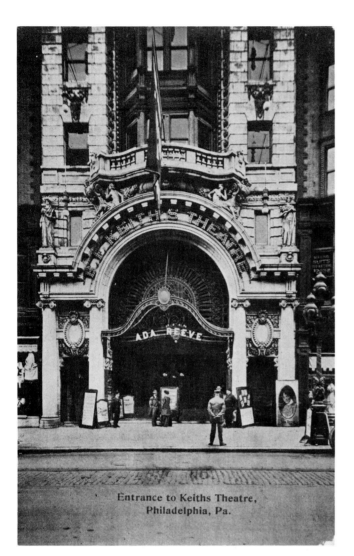

Entrance to Keiths Theatre,
Philadelphia, Pa.

Chestnut Street near 12th Street, 1914 (left) and 1909 (below): B. F. Keith was Philadelphia's most important vaudeville impresario when he opened this theatre on Chestnut Street in 1902. His first showhouse was at 8th and Race Streets in 1889 (later, this building became the "Bijou"), but his new theatre was designed to out-do every house that had come before. In some ways, it presaged the great movie palaces of the 1920's.

"Entering the vestibule," said a contemporary news account, "the visitor is awed by the immense proportions of everything visible." Most visitors *were* surprised to see the narrow facade open into an auditorium 118 feet wide. Past the marquee was the Grand Entrance Hall (below) with its marble floor, moveable ticket booth of polished mahogany, and murals by William Dodge—all under a magnificent domed ceiling. French doors opened into the Crystal Lobby (painted in ivory and gold), which was illuminated by two 100-lamp French chandeliers with "the iridescence of sunlight." On top of this (literally) was another ceiling mural entitled "The Toilet of Venus." All this was seen before the stage itself!

The auditorium had 18 boxes, a 260-lamp chandelier of inverted dome shape, columns of Italian marble, and an ivory-toned proscenium surrounded by dancing cupids. The seats were covered with cerise silk plush.

Ed Wynn, Al Jolson, Will Rogers, and Marie Dressler all played two shows a day at Keith's. Talking pictures delivered the final blow to vaudeville, and after 1930, Keith's was run by Paramount and later, M-G-M. In 1932, A. P. Keith willed his father's theatre to Harvard University which, after eleven years, sold Keith's to William Goldman. In 1949, Goldman gutted the interior, added stainless steel staircases and re-named it the "Randolph." With 2500 seats, it was the second largest movie theatre in town. In 1971, the Randolph, too, closed after a showing of *Tora, Tora, Tora!*

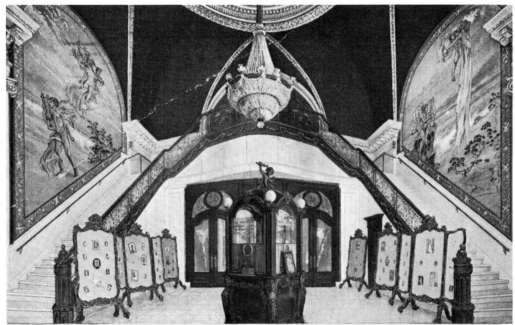

GRAND ENTRANCE HALL AND STAIRCASE, KEITH'S THEATRE, PHILADELPHIA

Juniper and Chestnut Streets, 1913: The Garrick Theatre, built in 1901 by William Whiteman, was a favorite of producers because its intimate size made it similar to the theatres of Broadway. Actors enjoyed the good acoustics and commodious dressing rooms near the stage. Many of the finest actors and actresses of the day held forth here, including John and Ethel Barrymore; Nazimova; and Lunt and Fontanne. Two unknowns made early appearances as well: Kate Smith (in a chorus) and Clark Gable (in a bit part.)

The lobby, which included a working fireplace and florist shop, was adorned with pictures of the notables who had performed here. The interior was styled after an English baronial estate—complete with dark wood panels hung with shields, swords, and axes.

But new palatial movie houses, burlesque shows, and radio combined with rising real estate prices doomed the Garrick to demolition in 1936 for a parking lot.

210. Garrick Theatre, Philadelphia, Pa.

Bristol Pike, Holmesburg, 1908: Edwin Forrest was one of the nation's first great tragic actors. He made his first appearance on stage at the Walnut Street Theatre at the age of fourteen years, and his last stage role in Philadelphia was in the same theatre in 1871. He helped foster the beginnings of American drama by offering prizes for original plays. Forrest (for whom the Forrest Theatres on Walnut and Broad Streets were named) left a large bequest to improve the rather poor lot of retired thespians, and apartments were made available to them in "Springbrook," formerly the country home of Caleb Cope.

The home was relocated to 4849 Parkside Avenue in 1928, and Springbrook was demolished. In 1988, the home was closed due to a lack of clientele, and Forrest's collection of theatrical memorabilia was donated to the Historical Society of Pennsylvania. The money remaining from the original endowment was transferred to the actors home in Englewood, New Jersey.

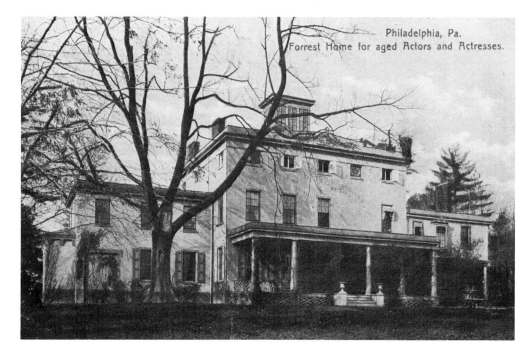

Philadelphia, Pa.
Forrest Home for aged Actors and Actresses.

Hotels and Restaurants

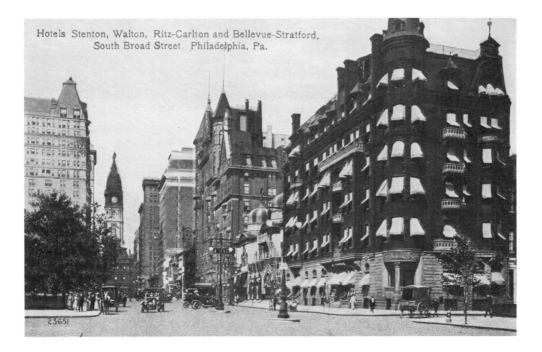

Hotels Stenton, Walton, Ritz-Carlton and Bellevue-Stratford,
South Broad Street, Philadelphia, Pa.

Philadelphia Hotels: Looking up Broad Street in about 1910, these hotels just south of City Hall could be seen. On the right, at the northeast corner of Spruce Street, is the Stenton Hotel, opened in 1893 by Joseph and Hannah Fox. At that time, the Stenton was considered the most luxurious hotel in town. Every room had its own fireplace, tapestry, and etchings. The halls, finished in walnut, were hung with painted portraits, scenes of Venice, and gilt candlesticks. In the center of its opulent dining room was a great carved mahogany pillar with a ferocious gorgon atop it. When the Stenton closed in 1927, the old registers recorded names such as I. Jan Paderewski, John Drew, the Barrymores, and Lillian Russell. It was torn down in 1929.

Moving left, the Broad Street Theatre is next in line and then the Hotel Walton, both described elsewhere. The next, rather squarish building is the Ritz-Carlton; across Broad Street on the far left is the Bellevue-Stratford.

74

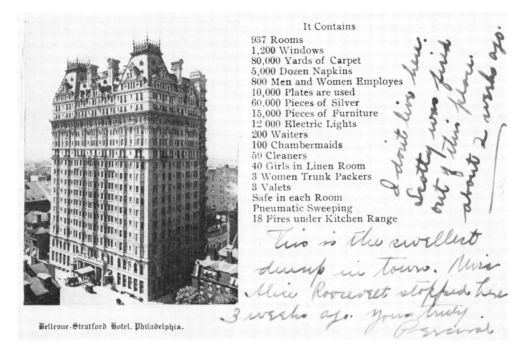

It Contains

937 Rooms
1,200 Windows
80,000 Yards of Carpet
5,000 Dozen Napkins
800 Men and Women Employes
10,000 Plates are used
60,000 Pieces of Silver
15,000 Pieces of Furniture
12,000 Electric Lights
200 Waiters
100 Chambermaids
59 Cleaners
40 Girls in Linen Room
3 Women Trunk Packers
3 Valets
Safe in each Room
Pneumatic Sweeping
18 Fires under Kitchen Range

Bellevue-Stratford Hotel, Philadelphia.

Broad and Walnut Streets: G. W. & W. D. Hewitt were the architects for the city's most famous hostelry. It has had a varied and sometimes star-crossed life. Uncounted Philadelphians have been toasted, bar mitzvahed, elected, graduated, and generally pampered in this 19-story Victorian French Renaissance building since its 1904 opening. Every President from Teddy Roosevelt to Gerald Ford has been hosted here as have been the city's most important social and political events.

But a bizarre outbreak of a previously undiscovered disease closed the Bellevue in 1976 after a Legionnaires' convention. Three years later, however, the "Belle of Broad Street" reopened as the Fairmount Hotel; in 1980, its name was changed back to Bellevue-Stratford. The hotel was again closed in 1986 for a massive renovation and re-opened in 1989 with 180 luxury rooms on the top seven floors. The lobby, the most elaborate in any Philadelphia hotel, has been preserved along with a number of previously hidden interior details. Two new atriums have also been added.

The above card contains some impressive statistics as well as a note from "Percival." The cartoon (right) puts the lie to Philadelphia's reputation for rolling up the sidewalks after midnight.

PHILADELPHIA AFTER MIDNIGHT

Drinking high balls, very high,
In a garden near the sky,
Up above the world were we,
This was the way it looked to me.

BELLEVUE STRATFORD
HOTEL

COPYRIGHT, 1907, BY L. W. BLASIUS

1912 (right) and 1914 (below): Rumor had it that a member of the wealthy Widener family, angered that his wife was not allowed to smoke at the Bellevue-Stratford, vowed: "If she can't smoke in that hotel, I'll get one built she can smoke in." At any rate, the Wideners opened a branch of the famous Ritz chain here in 1912.

The base was of pink granite, the second story was of Indiana linestone, and the third and other floors were of rough brick. Special plugs were provided in each room for curling irons. It shortly supplanted the Stenton as "The Place" for society gatherings such as the Assembly Ball, Mardi-Gras, and the Opera Supper.

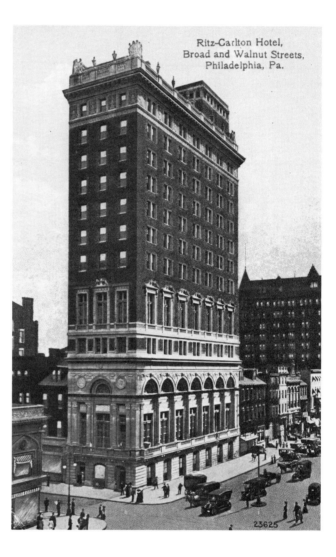

Ritz-Carlton Hotel, Broad and Walnut Streets, Philadelphia, Pa.

Ritz-Carlton Hotel, Philadelphia, Pa.

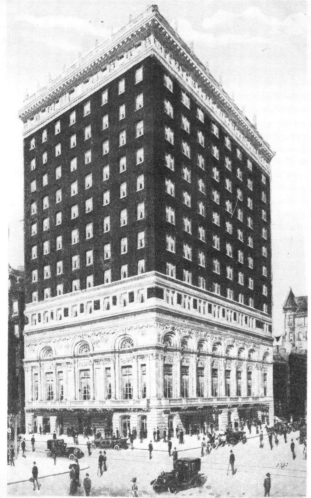

During Prohibition, a magistrate who was dubbed the "Dancing Judge" began raiding hotels for liquor. One such raid broke up the debutante party of the year, held at the Ritz-Carlton. However, the father of one of the debutantes stated: "There was no hugging, as alleged, nor any other impropriety at my daughter's party."

Business was so brisk that, just two years after its opening, the hotel doubled in size, as shown at left. And, not to be outdone by the competition down the street, the register here included the names of Sergei Rachmaninoff, Enrico Caruso, and dozens of movie stars, princes, and politicians. However, in 1938, the Ritz entered bankruptcy court; after a few year's respite, the hotel closed for good in 1954. The building remains today with some alterations and minus the top cornice.

Mr. Widener (who, by the way, went down with the Titanic after a hiring trip to Europe) would no doubt be pleased to know that, in 1990, the Ritz has risen again, this time at 17th and Chestnut. The restaurant has a no-smoking section.

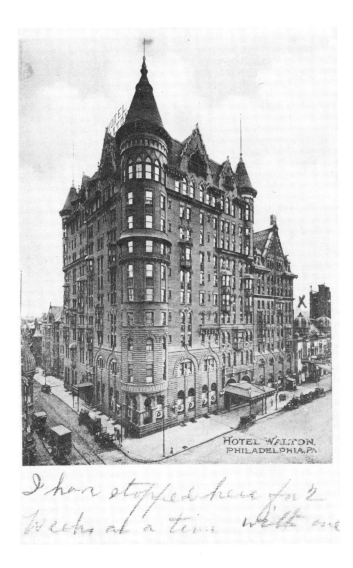

South Broad and Locust Streets, 1909: This elegant brick and stone hotel was just across the street from the Academy of Music and right next door to the Broad Street Theatre, visible to the right here.

It was opened in 1895 by Robert Walton Goelet at a cost of $2,000,000 and received remodellings in 1914 and 1925. In later years, one of the city's more popular (judging by the number of times it was raided) watering holes was the night club on the top floor. In 1945, the club caught fire and the management was unable to comply with the needed alterations to meet the fire codes. The Walton went bankrupt and was sold at a sheriff's sale in 1946 for $421,000. It was reborn as the John Bartram Hotel. This reincarnation ended in 1962 when the building was torn down. Today, the glass-walled Hershey Hotel serves visitors on this spot.

Miss Diggles, who sent this card, says: "I stopped here for 2 weeks at a time with one lady. Five dollars a day for room, no meals with separate beds. Everything first class on the fifth floor."

The lobby as it appeared in 1908 is shown below.

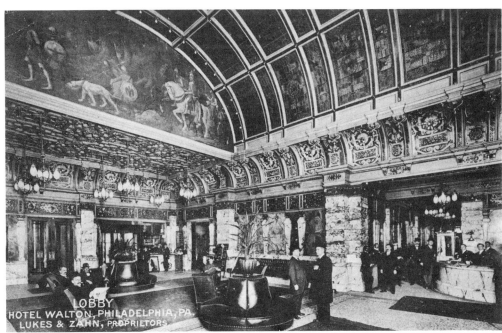

The Robert Morris was built as a six-story office building in 1914 by the Methodist Board of Missions. In 1922, eight new floors were added, and the Wesley Building became the Robert Morris Hotel. It was leased to the Ryerson W. Jennings Company, which operated strickly "dry" hotels in the city and the Pocono resort area. The constabulary had no worries about the Morris during Prohibition. In fact, the hotel stayed dry even after the amendment was repealed. The Morris attracted a sedate and international clientele. Much of its staff was bilingual.

In 1971, the building was sold to the Philadelphia College of Bible for $1.3 million, and used for classrooms and dormitory space. After several subsequent changes of ownership, it stands today once again as an office building.

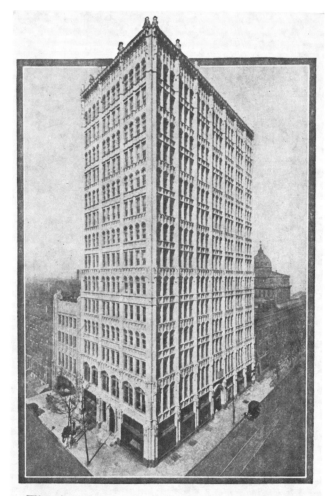

When in Philadelphia stop at THE ROBERT MORRIS
Philadelphia's newest and coolest hotel
Seventeenth and Arch Streets and the Parkway

Southeast corner of 16th and Market Streets, 1909: The Keystone began life in 1826 as ten rowhouses built by Isaac Lloyd. Just after the Civil War, a few walls were knocked out, a sign hung and—Violà!—it instantly became one of the city's oldest hotels.

Although definitely not luxurious, the Keystone had an excellent location only a block from the planned new City Hall. Unfortunately, that convenient address proved too valuable, and the hotel was leveled in 1926. Today, this area supports a phalanx of tall office buildings.

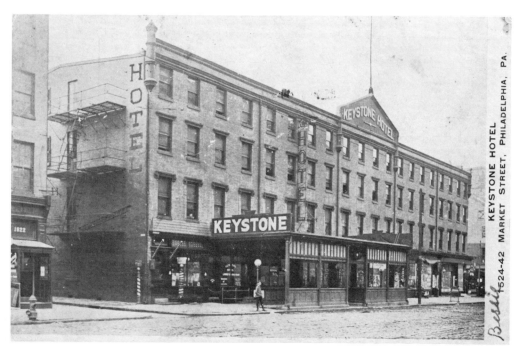

KEYSTONE HOTEL 1524-42 MARKET STREET, PHILADELPHIA, PA.

Southeast corner of 9th and Chestnut Streets: The 700-room Continental Hotel, designed by John McArthur in 1860, was the city's largest hotel for many years. It peaked in popularity during the Centennial celebration, hosting Great Britain's Prince Edward (later Edward the VII), among many notables.

After the turn of the century, it seemed every hotel in town had a "palm room"—a room with a few dozen potted plants and waiter service. The Continental carried this theme several steps further by creating what appeared to be a

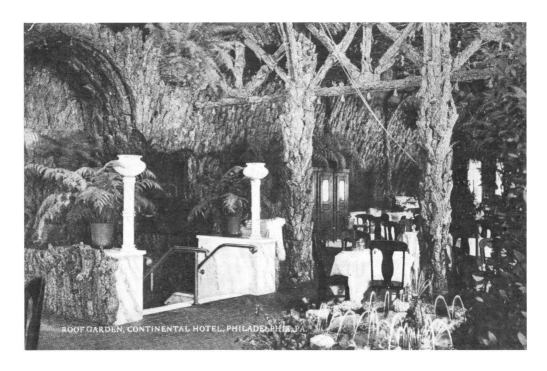

ROOF GARDEN, CONTINENTAL HOTEL, PHILADELPHIA, PA.

giant tree house (or giant fire trap, depending on how one viewed it). But the Continental was not concerned about fire safety—it had its own fire brigade and "escape ropes in every room." Even these amenities, however, failed to save the old hotel from demolition in 1923.

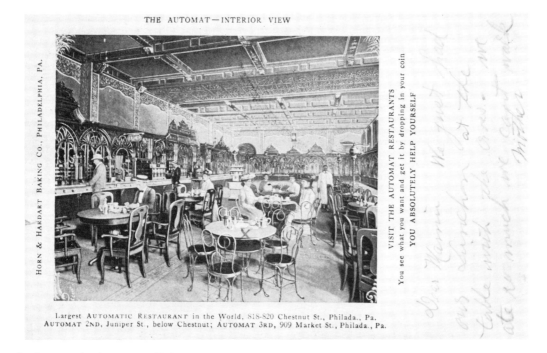

THE AUTOMAT—INTERIOR VIEW

HORN & HARDART BAKING CO., PHILADELPHIA, PA.

VISIT THE AUTOMAT RESTAURANTS
You see what you want and get it by dropping in your coin
YOU ABSOLUTELY HELP YOURSELF

Largest AUTOMATIC RESTAURANT in the World, 818-820 Chestnut St., Philada., Pa.
AUTOMAT 2ND, Juniper St., below Chestnut; AUTOMAT 3RD, 909 Market St., Philada., Pa.

1906: While vacationing in Germany in 1900, Philadelphia restauranteur Frank Hardart ordered $30,000 of "waiterless restaurant" equipment. He and his partner, Joseph Horn, then opened this, America's first "automat" in 1902.

The automat concept not only sped up service, but it insured that perishable foods were served at safe temperatures during a period of food contamination scares. Behind a baroque wall of beveled glass, nickeled brass, and marble, sandwiches, pies, beans, and rolls awaited nickel-slot liberation. The dolphin-shaped coffee spigots were Mr. Hardart's idea.

Horn and Hardart eventually opened automats in New York as well as Philadelphia, serving as many as 800,000 meals a day and, according to many, the finest cup of coffee in town.

The original Chestnut Street automat closed in 1968 and was given to the Smithsonian Museum of American History.

By the 1930's, there were five dailies in the city: *The Morning and Evening Public Ledgers, The Inquirer, The Evening Bulletin,* and *The Record.* In the 1920's, *The Record* was the lone Democratic paper in the city and took regular shots at the Republican machine. Ironically, now that the Democrats control City Hall, *The Record* is no more; only *The Inquirer* and its sister paper, *The Daily News,* remain.

The Record Building was at the southeast corner of North Broad and Wood Streets. Designed by Willis Hale in 1880 and looking rather like a Scottish castle, it was covered with terra-cotta tiles and was the location of the Pierce Business School and, in the tower with the clock, Penn Mutual Life. Note the name of the paper emblazoned on the square tower. Both structures were demolished in 1932 for the Federal Reserve Bank. The Victory Building, just west, still stands.

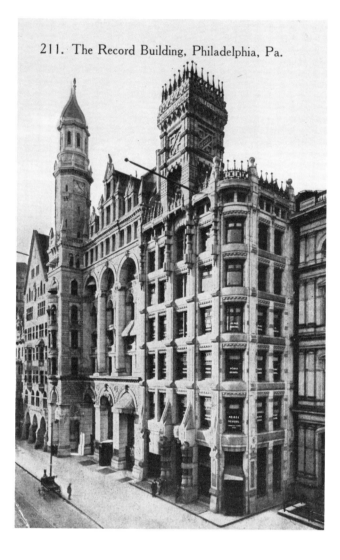

211. The Record Building, Philadelphia, Pa.

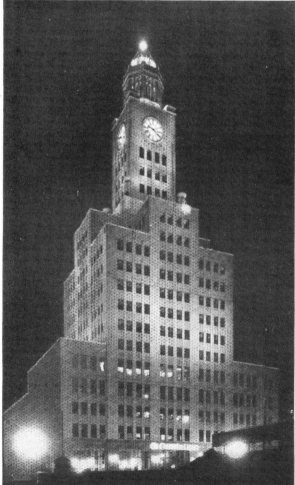

114 ELVERSON BUILDING AT NIGHT.

HOME OF THE PHILA. INQUIRER, PHILADELPHIA, PA. 109601

The Inquirer was published in the 1924 Elverson Building at 400 North Broad (the paper was in the Elverson family from 1889 until the 1930's). It was designed by Rankin, Kellogg, and Crance of buff-colored brick and terra cotta. High on top was a lantern and a small gold dome. The color-plate presses could be seen in action through the street-level windows. *The Inquirer* and *The Daily News* are still headquartered here, although *The Record,* along with its headquarters, is gone.

No. 5. Getting News by Telegraph for THE PHILADELPHIA RECORD.

This is one of a series of cards showing the operations of *The Philadelphia Record* newspaper. Today, news is flashed over teletype or satellite and forgotten is the revolution created by the simple telegraph. Previously, news stories took days to be transmitted by mail or messenger, but the telegraph allowed instant sending and receiving of the day's stories. The job was obviously a hectic one—notice the crumpled papers on the floor. One can only imagine the results of an eight-hour day spent in this position.

121 South Broad Street, 1914: *The North American* called itself "the oldest newspaper in the country" when reform-minded John Wanamaker purchased it in 1898. Actually, *The North American* name was coined in 1839, but it had absorbed Benjamin Franklin's *Pennsylvania Gazette*, which gave it an historical pedigree. Wanamaker claimed never to have controlled the editorial content of this paper, but it echoed his disapproval of Philadelphia machine politics.

Thomas Wanamaker supervised the construction of this sturdy building in 1900, and the paper was printed here until its last edition in 1925 when it was bought out by the Cyrus Curtis' *Public Ledger*. In 1981, the empty building was restored and is used for offices today.

In the foreground is the original Forrest Theatre, which opened in 1907. It was a spacious, three-level theatre with access to all seats via a system of ramps. Its owners drove a car through the aisles to demonstrate how commodious they were. The Forrest (named for local tragedian Edwin Forrest) played mostly musical comedies and hosted George White's *Scandals*, Ziegfeld's *Follies*, and George M. Cohen's *Revues*. In 1915, the Forrest set up a screen to offer the city premiere of D. W. Griffith's *Birth of a Nation*. Its valuable location proved the theatre's doom, and it was demolished to make way for a bank in 1927, only twenty years after it opened. In 1928, however, a new Forrest Theatre opened at 1114 Walnut Street and remains the city's leading legitimate theatre to this day.

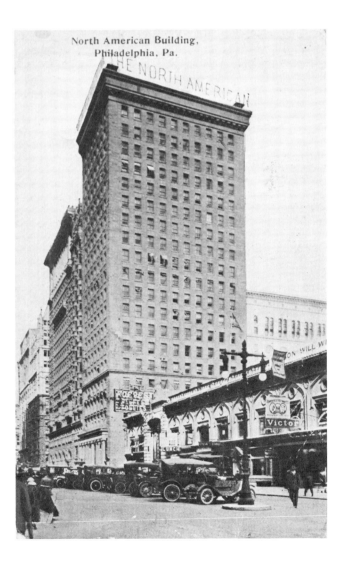

North American Building, Philadelphia, Pa.

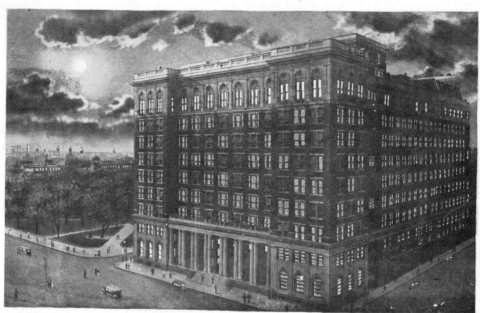

CURTIS PUBLISHING CO., INDEPENDENCE SQUARE, PHILADELPHIA, PA.

1914 (above) and 1912 (below): This factory and office building was designed in 1910 by Edgar Seeler to harmonize with the historic Independence Hall buildings across 6th Street (if such a concept is possible with a building twelve stories tall having 23 acres of floor space). Here were assembled and printed some of the most popular magazines of the first half of this century: "*The Saturday Evening Post,*" "*The Ladies' Home Journal,*" and "*The Country Gentleman.*" It contained 200 presses and soundproofed editorial rooms. The lobby had a large Tiffany mosaic from a sketch by Maxfield Parrish based upon his painting "The Dream Garden," which hung in the executive dining room. Parrish also painted sixteen panels in the ladies' dining room.

In 1937, total output was 17,000,000 magazines per month. The Curtis Building (now Curtis Center) remains, although it is no longer a printing plant.

The Curtis amenenities in 1912 included the Women's Recreation Room, shown below.

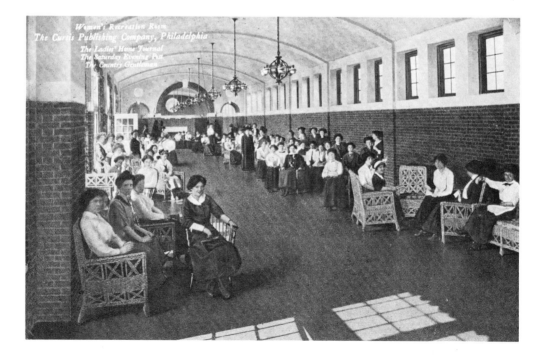

John B. Stetson Company, 5th Street and Montgomery Avenue: Mr. Stetson came to Philadelphia in 1865 with $100 and an interest in making hats. Profits were meager until he introduced his "Boss of the Plains": a ten-gallon hat that Westerners (to the surprise of Philadelphians) bought with a vengeance.

In all, twenty buildings were constructed for the company between 1874 and 1930 with thirty acres of floor space and, in busy times, 6,000 employees. It established a Sunday School, auditorium,

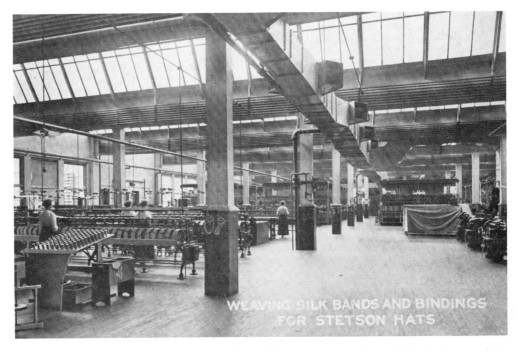

WEAVING SILK BANDS AND BINDINGS FOR STETSON HATS

library, hospital, building and loan, and citizenship classes for its employees. The company made everything in its own plants, including hat bands, ribbons, and boxes. Fifteen million fur skins were used annually.

Changing styles forced the company out of business in 1971, and their buildings were acquired by the city in 1977. Some were demolished in 1979, and others were destroyed by fire in 1980.

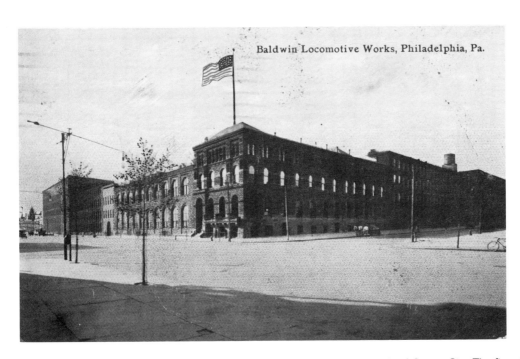

Baldwin Locomotive Works, Philadelphia, Pa.

Broad and Spring Garden, 1914: In their shops at 4th and Walnut Streets in 1832, Matthias Baldwin and David H. Mason built their first locomotive and named it *Old Ironsides*. It was known as a "fair weather engine" because it was not heavy enough to generate sufficient traction to keep it moving in the rain. During bad weather, it was replaced by horses.

Baldwin's Locomotive Works became by far the most important steam locomotive manufacturer in the world (1,500 machines produced per year by 1902) and moved to this 20-acre site north of Center City. The firm then moved to Eddystone (near Chester, Pennsylvania) in 1928 and shut its doors for good in 1972 when it was manufacturing bulldozers and cranes. These buildings were razed in 1937.

Old Ironsides is on display in the Franklin Institute and, to this day, many Baldwin locomotives see daily service throughout the world.

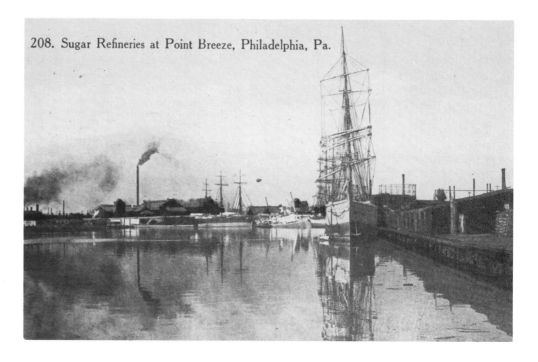

208. Sugar Refineries at Point Breeze, Philadelphia, Pa.

1915(?): There were several sugar refiners along the Delaware. The largest was the Pennsylvania Sugar Company at Delaware Avenue and Shackamaxon Street just south of Cramp's Shipyard. The first sugar refinery in the country opened in 1783 on Vine Street above Third Street.

The author cannot identify this particular processor, but all of them operated pretty much in the same way: dark brown raw sugar was imported from Cuba, Puerto Rico, the Philippines and Hawaii (square-riggers were still used for the short hauls). This raw sugar was heated, strained, pulverized, sorted, packaged, and shipped to pantries and stores all over the world. During this period, Philadelphia was the second largest sugar processor in the world. The last sugar refinery left the city in the 1970's.

Shortly before the Civil War when the old 1798 Naval Yard was found unsuitable for the construction of iron ships, the city of

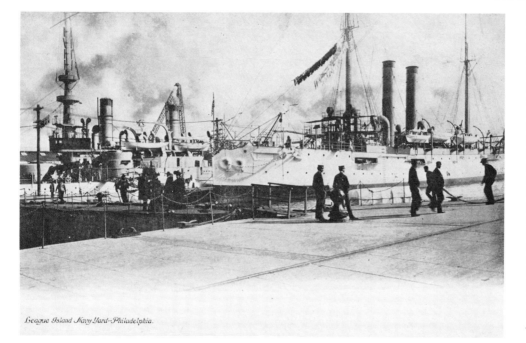

League Island Navy Yard-Philadelphia.

Philadelphia purchased 923-acre League Island for $310,000 and, anxious to retain their ship-building business, presented it to the Federal Government. Philadelphia offered the advantages of a skilled labor force and fresh-water docking, so the government willingly accepted the offer. Ships were constructed here for every conflict from that time to this, and the Yard remains active today refitting ships of all kinds for the U. S. Navy including, in 1981, their largest aircraft carrier—the *Saratoga*.

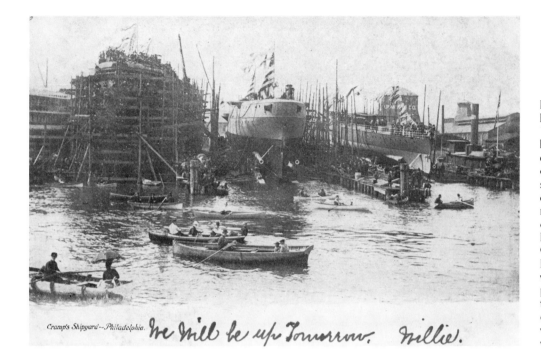

Cramp's Shipyard—Philadelphia.

Norris Street and Delaware Avenue, 1906: In 1830, William Cramp used his earnings as a ship's carpenter to begin a small ship-building operation at what is now East Susquehanna Avenue. By 1872, William Cramp & Sons Ship Building Company was a $500,000 corporation and one of the largest such operations in the world. Cramp's built warships for the Navy and yachts for the wealthy.

To the right in this postcard can be seen the I. P. Morris Company, a subsidiary that ran the Port Richmond Iron Works, allowing Cramp's to manufacture its own iron and steel parts. The card shows a celebration preceding the launching of a new warship from dry dock.

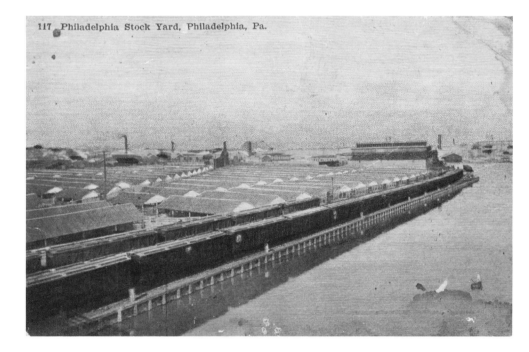

117 Philadelphia Stock Yard, Philadelphia, Pa.

30th and Race Streets: The old stockyards were built along the then not-so-scenic Schuylkill River in 1876 but were forced to close because of construction by the Pennsylvania Railroad. When City Council approved a site at 58th Street and Lindbergh Avenue, the residents displayed their unanimous objection—15,000 of them signing petitions against the plan. Philadelphians were well aware of the penalties of being downwind of the old stockyards along the river and were not comforted by promises of improved sanitation. In 1931, the new yards were built, instead, at 36th Street and Gray's Ferry Avenue where 6,000 cattle and hogs were slaughtered weekly.

Today, most meat is processed in the Midwest, and there are no major slaughter houses in the city.

Small Section of the Brainerd & Armstrong Dyeing Plant.

After the Civil War, Philadelphia became an important manufacturer of cloth and clothing. Brainerd & Armstrong, makers of silk thread, was one of the many firms in the city supplying the clothing industry. They moved to and from at least six locations, beginning business about 1871 at 108 South 54th Street. James P. Brainerd, Benjamin A. Armstrong, and Leonard Smith were listed as the partners in the firm in 1874 when it moved to 220 Market Street.

This view, dating from about 1910, was probably at their 1027 Arch Street location, which they occupied until the 1920's. No further listings appear for the firm after that date, so they were probably bought out by another company.

Espen Lucas Machine Works, 1341 Noble Street: Encouraged by heavy manufacturers such as Baldwin Locomotive and the city's two shipyards, Philadelphia industry made almost everything from nuts and bolts to the wrenches that tightened them. The largest maker of saws in the city was Henry Disston & Sons, which employed almost 3,000 workers and whose plants covered 65 acres. But there was still enough of a market for smaller firms such as Espen Lucas, which made an assortment of power saws. Partners in the business were Fred and Jacob Espen, and William Lucas

This card shows a belt-driven circular saw cutting an I–beam—without much in the way of bodily protection for the workers.

180 types & sizes of Machines for sawing all kinds of Material

Delaware River and Frankford Creek, 1903: The Arsenal was established on land purchased by the Federal Government in 1815. Previously, muskets and ordnance were stored in a stone barn on this site. After 1815, 281 buildings were added to the original barn, covering some 94 acres. Here, small arms and artillery shells were manufactured, and gunpowder was tested. Infantry equipment and standard gauges, scales, and testing equipment were also produced for government use.

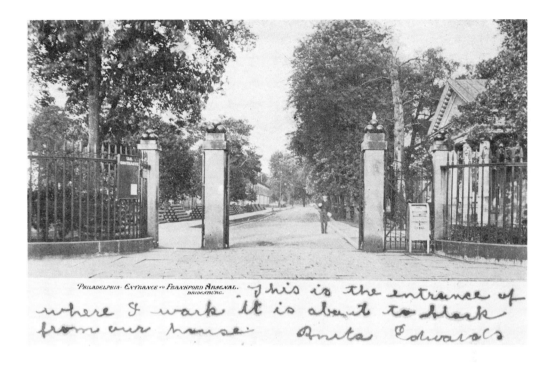

PHILADELPHIA ENTRANCE TO FRANKFORD ARSENAL.
BRIDESBURG.

"This is the entrance of where I work. It is about ½ block from our house." Anita Edwards

The Arsenal was closed in the late 1970's when the military found its needs adequately filled by private industry; since then, there has been much talk, but little action, regarding the preservation of the many interesting buildings on the site.

9 South Ninth Street: A second-hand bookstore much missed by local bibliophiles, Leary's was established in 1836 and occupied this site (where it moved in 1875) for almost a century. More than one celebrated "find" was made in its crowded shelves, including a copy of the first printed edition of the Declaration of Independence. Christopher Morley's *The Haunted Bookshop* is quoted on this card: "It would be as impossible for any bibliophile to pass this famous second-hand book store as for a woman to go by a wedding party without trying to see the bride."

When Gimbels Department Store expanded down 9th Street, it was built *around* Leary's, saving it until Gimbels itself was demolished in the 1970's. Leary's closed in November, 1968.

Department Stores

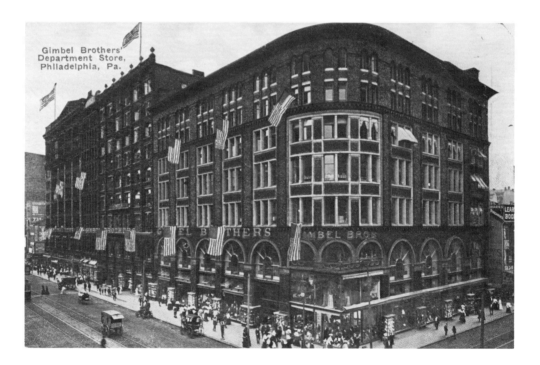

Market Street at 8th–9th, 1915: The Gimbel stores originated in Vincennes, Indiana, where Adam Gimbel opened a trading post offering honest dealings to all "whether they be Residents of the City, Plainsmen, Traders, or Indians." His seven sons, thoroughly trained in the business, brought the Gimbel gospel to Philadelphia.

Gimbel Brothers began business at this location in 1894 and steadily increased the size of their building until, in 1942, it occupied 50 acres of floor space. In 1901, for instance, the corner building here was increased by two floors and a fancy spire. The 1925 addition brought the building westward to Ranstead Street but spared Leary's Book Store (visible on the far right). In 1977, Gimbels moved to new $25,000,000 quarters across Market Street as part of The Gallery shopping mall, making it the first new department store to be built in an East Coast city in fifty years. The old store was demolished shortly afterward. Gimbels, itself, after barely five years in its new building, went out of business in the 1980's.

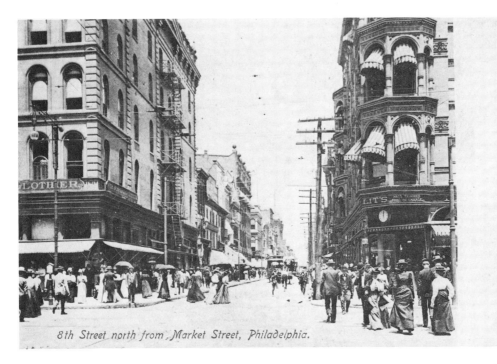

Lit Brothers, 8th and Market Streets: Samuel, Jacob, and Rachel Lit began their business at this corner in 1895; by 1907, Lit Brothers (Rachel notwithstanding) had acquired the entire block between 8th and 9th Streets. The various buildings, many with cast iron fronts, were preserved and their interiors joined to create the one large store shown here with its neighbor,

8th Street north from Market Street, Philadelphia.

Strawbridge & Clothier, opposite. The sign above the clock says: "Hats Trimmed Free of Charge." Ladies could choose from a selection of cloth flowers, feathers, ribbons, and other finery to get custom-made hats while they waited.

The new Market Street Subway proved a boon to business when it opened in 1908, but Lit's was finally unable to compete with suburban malls and closed in 1977. A succession of plans to save or demolish the structure all failed until, at the last moment, Mellon Bank agreed to lease 50% of the building for 25 years. Today, this landmark has been completely restored with the ground floors occupied by fashionable shops. The sign above the door still announces free hat trimming.

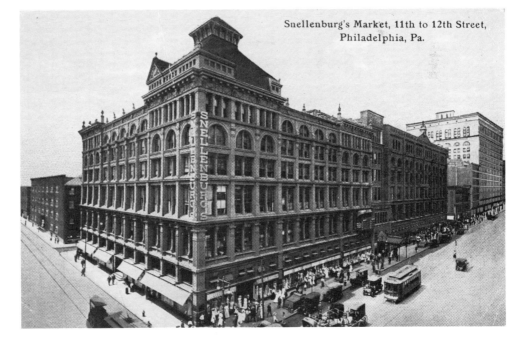

Snellenburg's Market, 11th to 12th Street, Philadelphia, Pa.

1912: Nathan Snellenburg, his brother Samuel, and Simon Bloch began the Snellenburg store in 1873 at 318 South Street selling men's clothing. Later that year, they moved to new 4,000-square-foot quarters at 5th and South Streets. From there, they eventually moved to this location across from The Reading Terminal. They followed the lead of John Wanamaker, Lit Brothers, and others in becoming a "department" store, offering almost anything purchasable under one roof.

Snellenburg's $1,000,000 1917 addition was opened by a parade of store cadets led by the Snellenburg Drum & Bugle Corps. Also like Lit's, Strawbridge's, and Gimbels, the Snellenburg store expanded into numerous buildings (five in this case), which were given a unified interior.

Descendants of the original founders retained ownership until 1951 when other investors took control. The last hurrah was a $5,500,000 remodelling in 1956, but it proved too late to save the old giant. Snellenburg's closed in 1963 after 90 years. The 6-story building was trimmed to two floors accommodating twelve tenants in 1965, and it remains thus today.

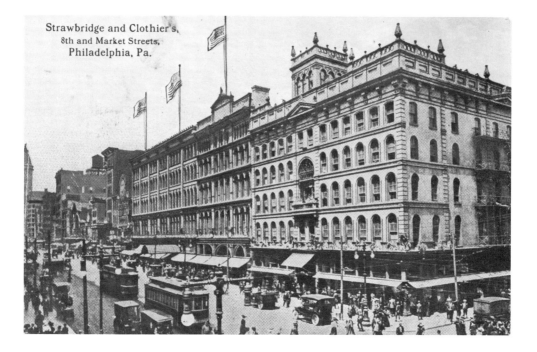

Strawbridge and Clothier's,
8th and Market Streets,
Philadelphia, Pa.

1916 (above) and 1909 (below): This is the oldest of the city's great department stores. Justus C. Strawbridge rented a three-story brick building on this site (where Thomas Jefferson had his office as Secretary of State) in 1861. Other store owners had tried and failed in the dry goods business here, including J. Ross Hoopes' Cheap Store, Cowperthwaite & Co., and Hoopes, Brolasky & Supplee.

In 1867, Mr. Strawbridge invited a trusted fabric supplier, Isaac H. Clothier, to a summer in Haddonfield, New Jersey. "I knew," said Mr. Clothier later, " . . . that he was going to ask me to go into business with him." He did, and thus was formed a partnership made in clothing heaven. Their motto: "Small Profits, One Price, For Cash Only."

The corner building was enlarged to five stories that year and enlarged again in 1878 to the size shown in this postcard. The building to its left was added in 1887. A new 13-story building on this site was dedicated in 1932 by Robert E. Strawbridge, the original Mr. Strawbridge's grandson. The building with the central pediment still stands. Strawbridge's Philadelphia firsts: pneumatic tube system (1912), radio station ("WFI," 1922), and the Charge-A-Plate (1930). (So much for cash only.)

The card below shows Strawbridge's entrance from the Market Street subway, similar to those at Lit's and Wanamaker's. This card was sent only one year after the subway was built.

Subway Station At Strawbridge & Clothier, Philadelphia, Pa.

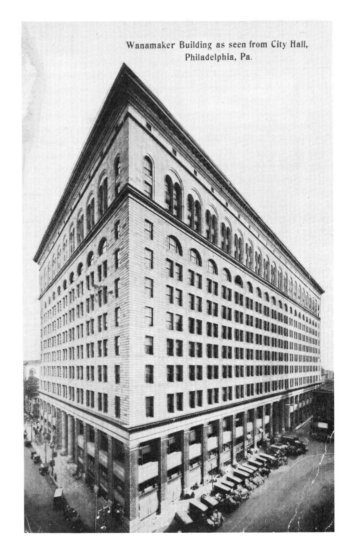

Wanamaker Building as seen from City Hall, Philadelphia, Pa.

Market and Chestnut Streets, 1902: John Wanamaker opened Philadelphia's first department store in the remodelled Pennsylvania Railroad freight depot at 13th and Market Streets (below). Contrary to the expectations of many, the store was hugely successful. In 1878, it was the first store in America lit by electricity. By 1910, this building was replaced with a building twelve stories high and a city block wide (right). It continues to attract shoppers today, although some of the upper floors have been converted to office space. Wanamaker's houses more than a department store, however. Above the huge bronze eagle acquired from the 1904 Louisiana Purchase Exposition is the second largest fully operational pipe organ in the world (exceeded only by the organ in Atlantic City's Convention Hall). It has 30,000 pipes and a full-time technician to maintain it. At this time, two free concerts are given daily.

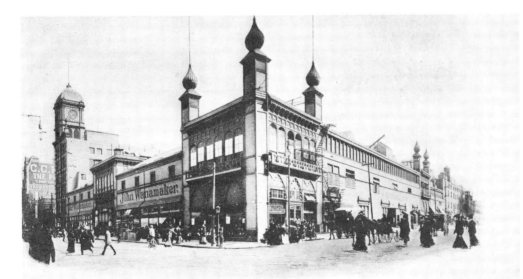

PHILADELPHIA—WANAMAKER STORE

Schools and Colleges

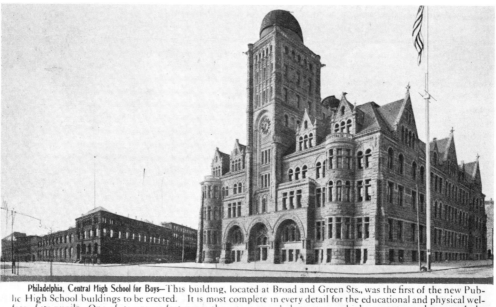

Philadelphia, Central High School for Boys—This building, located at Broad and Green Sts., was the first of the new Public High School buildings to be erected. It is most complete in every detail for the educational and physical welfare of its pupils. One of its unique features is the astronomical observatory, which is seen at the top of the tower. To the left can be seen a small section of Baldwin's Locomotive Works, the largest of its kind in the world.

1911: This card tells much of the story itself. Philadelphia's first high school was opened in 1839 on the present site of the John Wanamaker store with Alexander Dallas Bache, Benjamin Franklin's grandson, appointed as principal. This was to comply with an 1836 law that provided for the education of all children over the age of four years. A new $75,000 school was erected on the southeast corner of Broad and Green Streets in 1854; it was condemned in 1937. In 1900, the school pictured on the card was erected at a cost of $1,500,000 with not one, but two observatories, the larger of which burned in 1905. Central was palatial by today's high school standards with a planetarium and 280 square feet of Tiffany-stained glass.

Enrolling in Central meant being a male with an I. Q. of over 110 and a "good" average in all subjects for the previous two years. In 1939, Central became even less central when it moved to Ogontz and Olney Avenues. The old school was torn down and replaced by Benjamin Franklin High School.

A very important date is 1975 when the U.S. District Court ordered that Boy's High School be opened to girls.

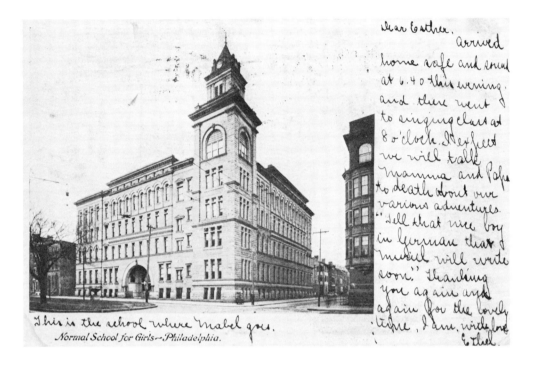

Normal School for Girls—Philadelphia.

13th and Spring Garden Streets, 1908 (above) and Botanical Department, 1916 (below): A "normal school" prepared students to be teachers, and teachers were sorely needed by the city's growing number of grammar schools. The first Philadelphia High School for Girls was begun in 1848 with 88 students and five teachers. The school day was five hours long and included reading, grammar, drawing, writing, and math. The 1877 Philadelphia high school for Girls, located at 17th and Spring Garden Streets, was a normal school until this school was built in 1893; from then on, it taught college preparatory, business, and general courses. Normal school training was discontinued in 1938, and this building no longer stands. The schools in the city are now co-educational.

Below is a view of the school's Botanical Department, circa 1916.

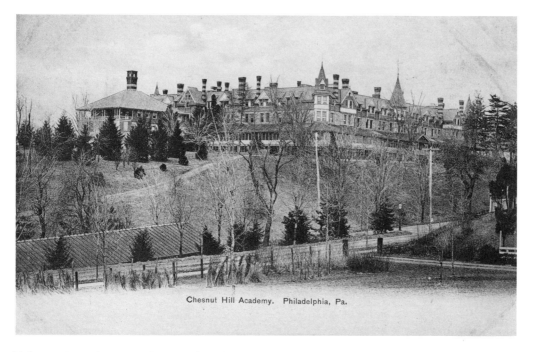

Chesnut Hill Academy. Philadelphia, Pa.

500 Willow Grove Avenue: G. W. and H. D. Hewitt designed this 235-foot-wide building for a summer resort hotel called The Wissahickon Inn in 1883. Its owner was Henry H. Houston, railroad entrepreneur and the original developer of Chestnut Hill, which is the highest point in the city and just north of Germantown. This building has been the Chestnut Hill Academy since 1898. The open porches around the outside of the old hotel were removed in 1928.

When David Sexias took a half-dozen deaf waifs from the streets of Philadelphia to educate them, their handicap was considered hopeless, but so successful were his courses that, in 1820, a school was started and moved from Sexias' home to the southeast corner of 11th and Market Streets (the former Mansion House Hotel) and then to the corner of Broad and Pine. (The Pine Street building, designed by John Haviland in 1824, is now the Philadelphia College of Art.) Still growing, the Institute

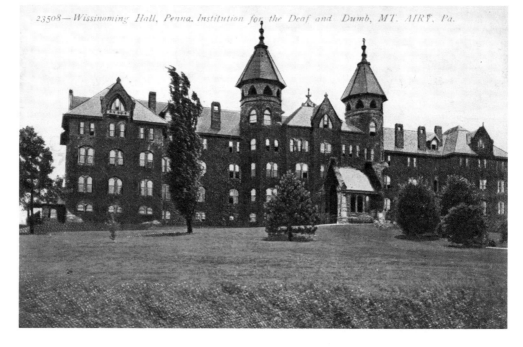

moved to this 35-acre site with nine buildings in 1892 and offered training in printing, tailoring, sign painting, woodworking, etc. The state contributed a sum for "every indigent mute child of suitable age." This sum was $160 in 1820, and $8,500 in 1976. The school's holdings grew to over 60 acres by the 1950's; in 1958, it donated five-and-a-half acres to Fairmount Park. After weathering some financially rough times, the Pennsylvania School for the Deaf—as it is called now—continues its important work.

Wissinoming Hall, shown here, still stands, but without the two tower roofs.

64th Street and Malvern Avenue, 1910: Designed by Cope & Stewardson in 1897, here is an elaborate and rare specimen of the Mission style in the Eastern U. S. It is of yellow plaster over stone with terra-cotta trim and tiled roofs. It is built on a large (400 feet wide) rectangular plan with two spacious courtyards. The auditorium behind the central rotunda burned in 1960 and was replaced with a reinforced concrete structure a year later.

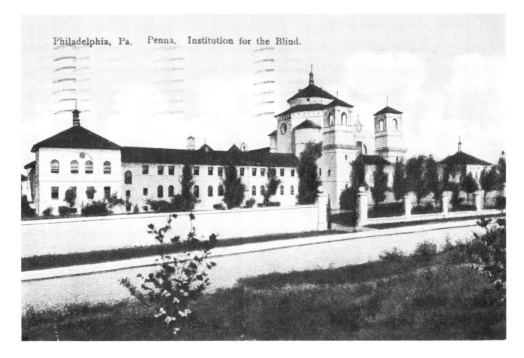

Philadelphia, Pa. Penna. Institution for the Blind.

Founded in 1834, this is one of the oldest institutions for the blind in the country, and one of a number of charitable facilities constructed in west Philadelphia in the last part of the nineteenth century. Its full name was Pennsylvania Institution for the Instruction of the Blind; this was changed in 1948 to Overbrook School for the Blind.

34th Street and Woodland Avenue: The University of Pennsylvania was founded in 1749 by Benjamin Franklin and a group of citizens interested in the education of Pennsylvania's youth. Franklin served as president of the board of trustees when classes began in 1751 in a two-story brick building at 4th and Arch Streets. "Penn," as it was called, began the first medical and law schools in the nation.

The school moved to its present site in 1872. The campus covers over 100 acres with more than 160 buildings. The University has employed many of the great collegiate architects including Frank Furness (library), Lewis Kahn (A. N. Richards Medical Research Building), and Thomas W. Richards.

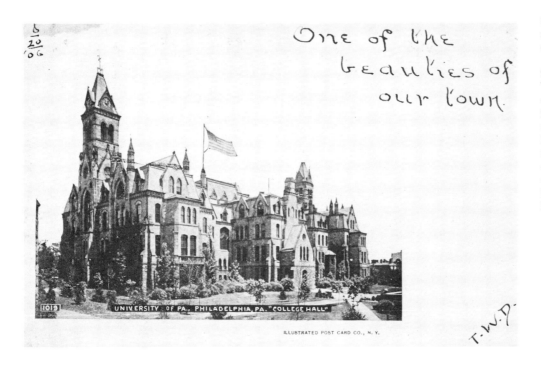

One of the beauties of our town.

UNIVERSITY OF PA., PHILADELPHIA, PA. "COLLEGE HALL"

ILLUSTRATED POST CARD CO., N. Y.

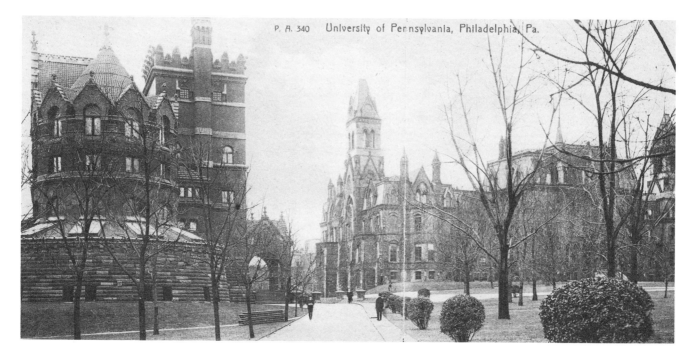

The building on the left is Frank Furness' library. College Hall, on the right, was built in 1872 and designed by Thomas W. Richards (see page 97). It is quintessential "College Gothic," built of local green serpentine sandstone, and considered the best-planned collegiate structure of its day. It housed the Departments of Science and Liberal Arts plus a chapel, assembly rooms, the library, and offices. Its two tall towers at either end and the smaller pinnacles were removed in 1914 and 1929.

"The White House Cafe" was located at 3557 Woodland Avenue, opposite the Men's Dorms, here pictured with its proprietor. "Thought you might like to see where I eat," says the sender of the card to his mother. The blackboard menu lists a baked apple at five cents.

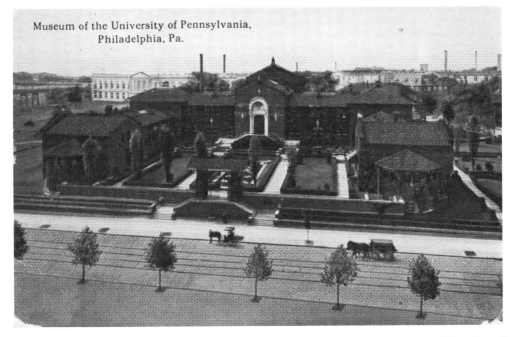

Museum of the University of Pennsylvania,
Philadelphia, Pa.

33rd and Spruce Streets, 1918: Construction began in 1893 for the Department of Archaeology of the University of Pennsylvania; now it is known as just "University Museum." Wilson Eyre, Jr., was chiefly responsible for the 12th century Romanesque villa design with reflecting pool and elaborate plantings. It is of brick with white and colored marble trim with sculptures at the entrance by Alexander Calder. Various additions were made in 1912, 1926, and 1969.

It remains today one of the world's leading archaeological museums, curator to artifacts from the almost 300 expeditions that the University has sponsored.

The imposing structure to the left is the Commercial Museum (see page 67).

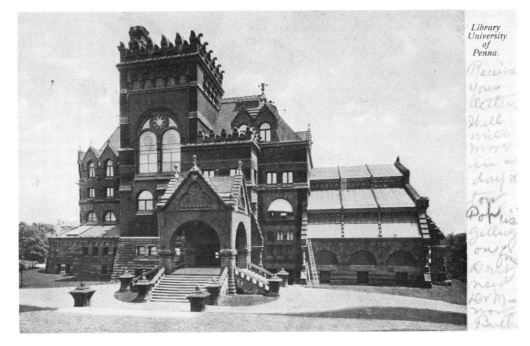

*Library
University
of
Penna.*

Near 34th and Walnut Streets, 1906: Frank Furness (pronounced like "furnace") was, perhaps, the greatest of Philadelphia's late 19th century architects. He designed buildings in an eclectic style with elements of classical revival, Moorish, and Gothic—plus a little humor. Several of his buildings have been preserved, and this is one of the most important (along with the Pennsylvania Academy of the Fine Arts). It was erected in 1888–1891 of brick, redstone, and terra cotta with a tiled roof. An impressive iron staircase leads to two of the original reading rooms through a glass walkway. The detail work of the interior is, to put it mildly, impressive.

THE TEMPLE UNIVERSITY, PHILADELPHIA, PA.

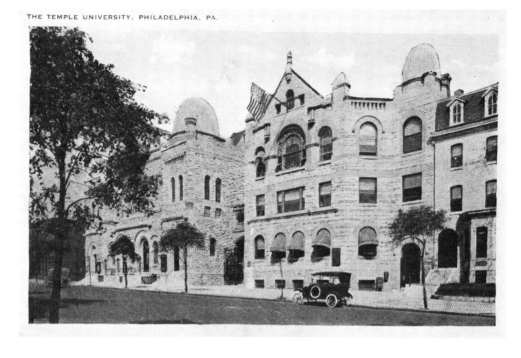

Broad and Berks Streets, 1923: The best decision that the congregation of the Grace Baptist Church ever made was to hire Russell H. Conwell to be its pastor in 1880. Conwell was converted to Christianity during his service in the Civil War, and his powerful sermons and lectures turned the tired mission into the popular 3,000-seat temple shown to the left in this view. In 1884, Conwell obliged a young man's request to be taught religious courses at night. When the class grew to forty students, the idea for a college began. In 1888, when it received its charter, Temple College had an enrollment of 590 students. It became a university in 1907. Conwell endowed the University with the earnings from his tremendously popular lecture, "Acres of Diamonds," which combined religion with financial success. By 1925, when Dr. Conwell died, his school had 125,000 graduates.

Today, Temple has schools of law, medicine, art, and journalism, among others. The original buildings shown here still stand.

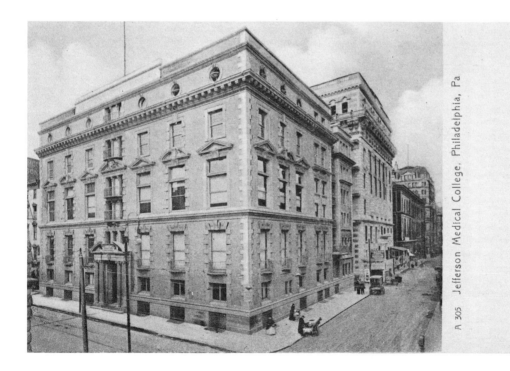

A 305 Jefferson Medical College. Philadelphia, Pa

10th and Walnut Streets: Jefferson Medical College was founded in 1824 as the medical department of Jefferson College in Canonsburg, Pennsylvania, and became independent in 1838. Colleges such as Jefferson helped increase the public's confidence in the medical profession, which was not universally respected at the time.

This view is looking northwest with 10th Street to the right. The corner structure was removed for the present Curtis Building, a fanciful design of terra cotta and orange brick built in 1931. The next large building just up 10th Street was built for the College in 1883 and still stands. Currently, interior alterations are being made—just as they appear to be in this card, but the outside of the building is basically the same.

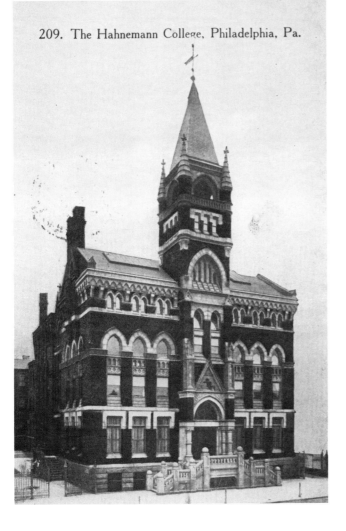

209. The Hahnemann College, Philadelphia, Pa.

Broad and Race Streets, 1913: Samuel Hahnemann, a German physician, developed homeopathic medical treatment in which small doses of drugs were administered "capable of producing in healthy persons symptoms like those of the disease to be treated." In 1848, the Homeopathic Medical College of Pennsylvania was the first institution to succeed in this field of instruction. In 1885, it merged with the Hospital of Philadelphia and occupied this Gothic brick building which, in turn, was razed in 1928 and replaced by a 20-story building designed by H. Hall Marshall. Homeopathic courses were discontinued in 1959. Today, Hahnemann is a highly respected teaching hospital.

32nd and Chestnut Streets, 1907: Drexel Institute, now Drexel University, was founded in 1890 by banker and philanthropist Anthony J. Drexel. The Main Building was opened in 1891 with Wilson Brothers & Co. as architects. It is of buff-colored brick with a granite basement and terra-cotta trim, and is about 200 feet square. A large marble entrance hall containing a bronze statue by Auguste Bartholdi (creator of the "Statue of Liberty") leads to a tall central court lit by a skylight. The building has been preserved and has a museum on the third floor that contains 19th century furnishings and art. Also on display is the David Rittenhouse clock of 1773, a complex mechanism that is probably the most important early American timepiece.

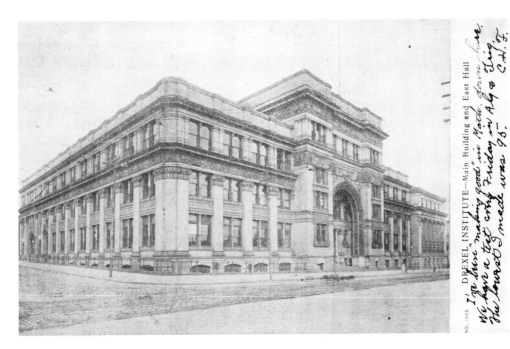

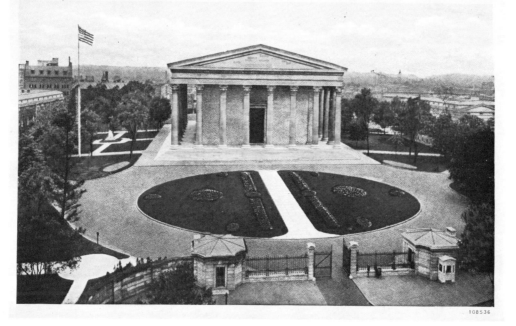

Girard Avenue and Corinthian Street: Stephen Girard ran away from home in France at the age of 14 years and took up work as a ship's cabin boy. By the time he was 23 years old, he became a captain, piloting his ship between New York, New Orleans, and the West Indies. In 1776, he arrived in Philadelphia after a narrow escape from British warships.

Here, he became a banker, merchant, and eventually, one of the richest men in America.

This early philanthropist established Girard College to educate boys without fathers. The school opened at its present site in 1848, seventeen years after Girard's death. Originally for whites only, it is now open to all.

Founder's Hall, completed in 1847, was designed by Thomas U. Walter, somewhat in violation of Girard's desires for a plain, utilitarian structure. It is one of the great examples of the Greek Revival style with 34 Corinthian columns atop a broad, stepped base. The roof is of marble tiles. Inside is a sarcophagus containing the remains of Stephen Girard as well as his important collection of 18th and 19th century furniture, glass, china, and silver; it is open to the public.

8th and Chestnut Streets, 1913: Founded in 1905 by S. Irving Strayer, this was one of a number of schools ready to train the army of secretaries and accountants needed by growing businesses. In June, 1920, *The Bulletin* wrote of the school's return to its newly renovated quarters with "spacious and brightly lit class rooms to comfortably seat the large number of students who will begin their courses."

A BOOKKEEPING ROOM - STRAYER'S BUSINESS COLLEGE, PHILADELPHIA.

During the 1925 graduation ceremony at the Academy of Music, the curtain lifted to reveal a modern office setting where the graduates demonstrated their typing, calculation, and dictation skills.

In 1935, the school's name was changed to "Strayer's Business School" and had an enrollment of about 800 pupils, but it no longer exists today.

Hospitals

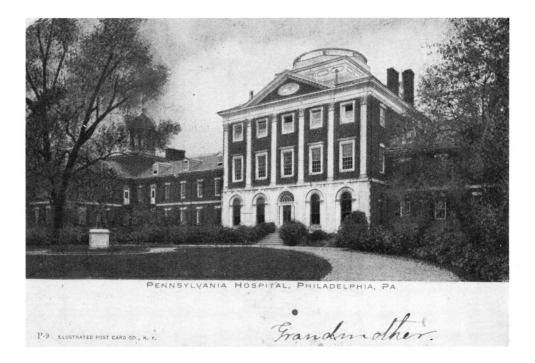

PENNSYLVANIA HOSPITAL, PHILADELPHIA, PA.

P-9 ILLUSTRATED POST CARD CO., N. Y.

Grandmother.

8th and Spruce Streets: This is the oldest hospital in the United States, founded in 1751 by Dr. Thomas Bond with the public relations assistance of Benjamin Franklin. This noble building had its cornerstone laid in 1754. The influential design was accomplished by a committee headed by the builder Samuel Rhoads, who later became mayor of Philadelphia. A dome was originally planned for the top, but this was omitted because of construction difficulties. In the front courtyard is a statue of William Penn acquired by his grandson John from a London junk shop in 1804.

The Pennsylvania Hospital was one of the earliest hospitals to care for the insane, and difficulty was encountered at first by curious crowds gawking through windows and wandering about the halls. To solve this problem, a high fence was erected and a four-pence admission charged.

The old "Pine Building," as it is now called, is a museum with a portrait gallery, library, and display of medical instruments. Also preserved is the country's first surgical amphitheater, last used in 1868. Benjamin West's painting of "Christ Healing the Sick" was donated by the artist and is still on display. The interior was recently completely restored.

Front Street and Lehigh Avenue: When land was donated to the Protestant Episcopal Church in the 1850's for a hospital, there was some debate over its distance from the city's population (about 3 1/2 miles from Center City in what was then open land). But the project went forward with Samuel Sloane as architect. The cornerstone was laid in 1860 and, after an interruption by the Civil War, the building was completed in 1875. It was considered the finest general hospital in the country and influenced the construction of many others. With some additions and deletions, the building still remains today. (Note the street light that could be lowered for service.)

317. Episcopal Hospital. Philadelphia, Pa.

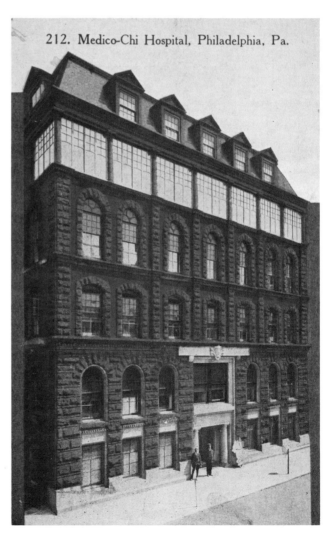

212. Medico-Chi Hospital, Philadelphia, Pa.

17th–18th Streets and Cherry Street, 1915: This name is short for "Medico Chirugical"—"medico" meaning "physician," and "chirugical" meaning "surgery." For some reason, this hospital was a fairly popular postcard subject, although this particular card was sent by a perfectly healthy tourist anxious to see the sights. Note the fifth–floor solarium.

For hospital buffs, it should be noted that the Medico-Chi was organized in 1849 but enjoyed little success until 1881 when it achieved a measure of prominence (for what reason, the author has yet to discover). At any rate, this spot is now a part of the Benjamin Franklin Parkway, and most who remember it are long past chirugical help.

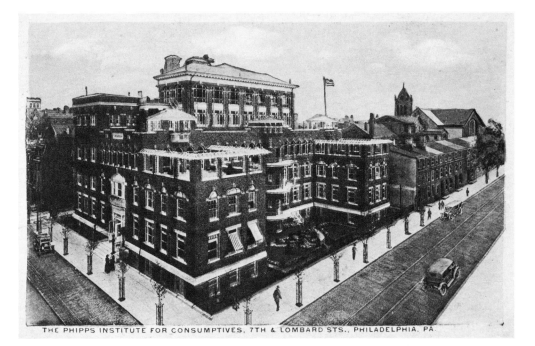

THE PHIPPS INSTITUTE FOR CONSUMPTIVES, 7TH & LOMBARD STS., PHILADELPHIA, PA.

1916: Consumption, better known today as tuberculosis, was probably more frightening than cancer early in this century. There were no antibiotics, and treatment consisted mostly of rest and fresh air (well, REST at least). Fortunately, TB is no longer a major killer, and the Phipps Institute is now a playground.

Tunnels, Bridges, and Ferries

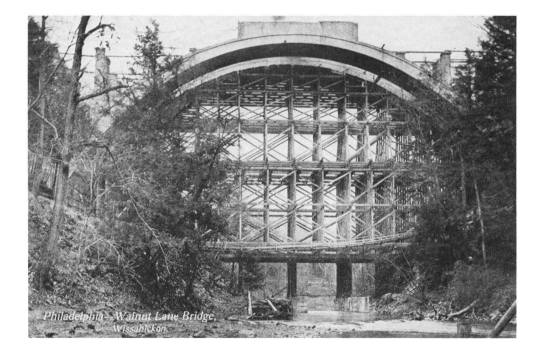

Philadelphia — Walnut Lane Bridge, Wissahickon.

1906: In the above postcard can be seen the massive wooden form bracing for the Walnut Lane Bridge. It was the largest concrete span in the world when it opened in 1907. Designed by George S. Webster and Henry H. Quimby, the 148-foot high, 585-foot long bridge used 40,000 tons of concrete and still carries traffic today. It was designed along classical lines rather like a Roman aqueduct, and for such a huge object, blends admirably with its bucolic surroundings.

Very soon after its completion, the bridge gained the popular name of "Suicide Bridge" since attempts of that sort rarely failed.

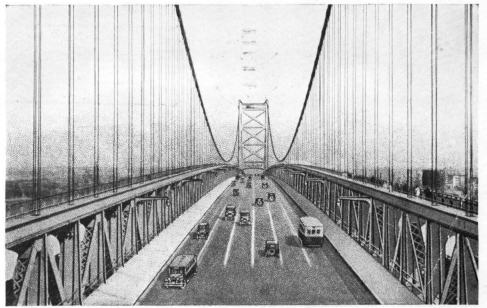

122 DELAWARE RIVER BRIDGE BETWEEN PHILADELPHIA, PA. AND CAMDEN, N. J. 118449

Until this bridge opened in 1926, only ferries crossed the wide Delaware River. It cost $37,000,000, is 1.81 miles long, and 125½ feet wide, allowing for a total of six lanes of traffic with rail lines along each side. Instead of using four cables for support, as was usual, chief engineer Ralph Modjeski used two, each thirty inches in diameter with 18,360 wires (by comparison, the Brooklyn Bridge used 15½–inch cables). The pedestrian footpath shown below was suspended above the train tracks on either side.

At the time, it was the longest suspension bridge in the world and still carries traffic across the River today under its new name: The Benjamin Franklin Bridge.

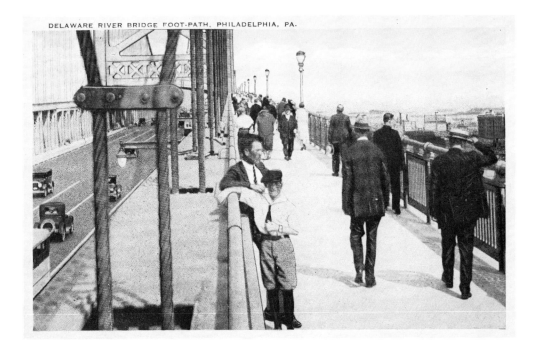

DELAWARE RIVER BRIDGE FOOT-PATH, PHILADELPHIA, PA.

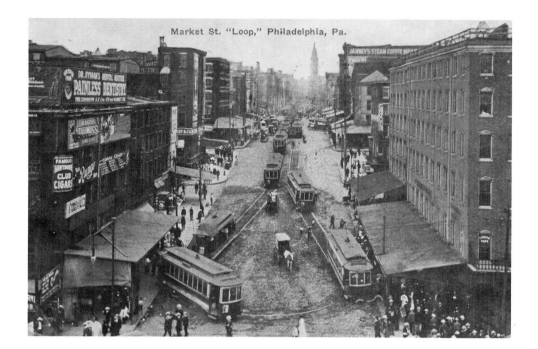

Market St. "Loop," Philadelphia, Pa.

1911: Passengers bound for New Jersey travelled by trolley to the eastern end of Market Street, exiting at Front Street under the sign for Dr. Hyman's Institute for Painless Dentistry. City Hall can be seen in the distance. Note the canopies covering the sidewalks—a long-lost courtesy to the pedestrian.

1908?: Just across Delaware Avenue was the Pennsylvania Railroad Ferry Terminal. Behind the terminal can be seen a ferry on its half-mile journey to Camden. The sign above the entrance announces "Electric Trains to Atlantic City," one of the most popular destinations in warm weather.

The trolley line was moved back to Front Street when the Delaware Avenue Elevated opened in 1908. The Pennsylvania Railroad's arch rival, The Reading, had its terminal one block south at the foot of Chestnut Street. Both ferry terminals are only history; today, these two views are obscured by Interstate 95, which now runs (or crawls, depending upon the hour) between Front Street and Delaware Avenue.

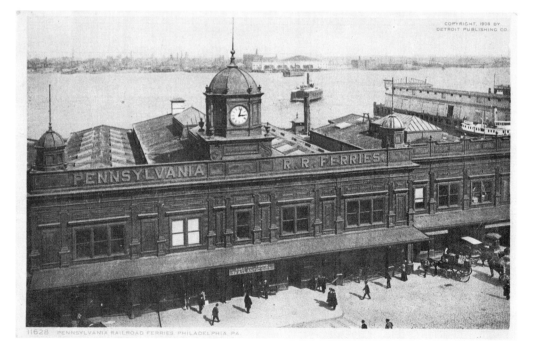

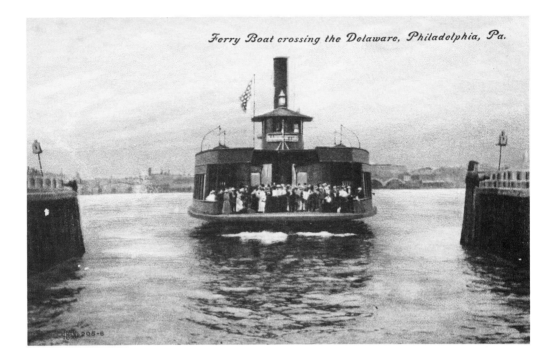

Ferry Boat crossing the Delaware, Philadelphia, Pa.

The half-mile wide Delaware River had no bridge from New Jersey into downtown Philadelphia until 1926, so the river itself served as a highway. New Jersey railroads built terminals on their side and sold trips to Philadelphia (including train and ferry) for one fare. On the Philadelphia side, trolleys brought travelers to within walking distance of the Delaware Avenue ferries, and the Delaware Avenue elevated train offered direct delivery to the Market, Chestnut, and South Street ferry terminals.

Above, we see a typical Delaware River Ferry with its single deck and cargo/vehicle area flanked by passenger compartments. Although the new bridges eventually ended this type of transportation, some ferries hung on until the 1960's.

At one time, steamers plied both the Delaware and Schuylkill Rivers. These were replaced with the more reliable petroleum-powered craft near the turn of the century. Below is the S. S. Burlington picking up passengers at Trenton.

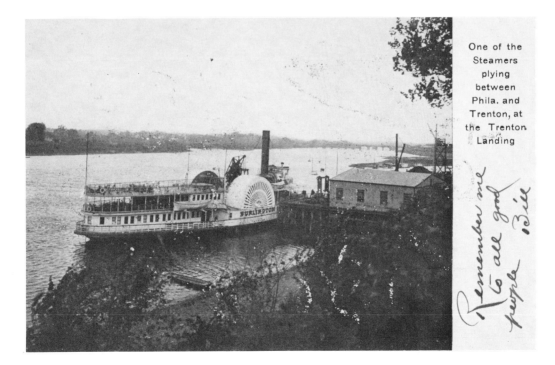

One of the Steamers plying between Phila. and Trenton, at the Trenton Landing

Germantown and Manayunk

Ask a Philadelphian where he is from and you will likely hear "Roxboro," "Olney," "Society Hill," or any of about a hundred other neighborhoods. Germantown and Manayunk, both roughly northwest of Center City, are two such neighborhoods. Germantown was founded in 1683 (only a year after Philadelphia itself) and, like Manayunk, derived its early wealth from weaving. It figured prominently in not only city, but United States history, hence its wealth of historical postcards. Manayunk, convenient to the powerful Schuylkill River, was an early convert to the Industrial Revolution.

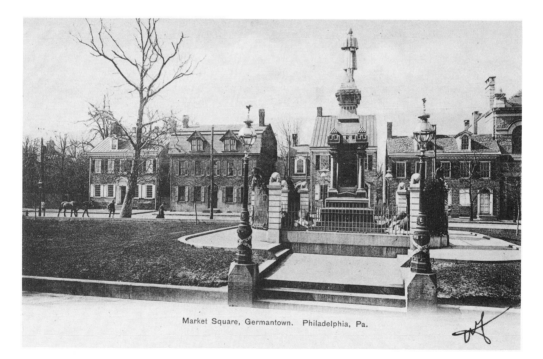

Market Square, Germantown. Philadelphia, Pa.

This centrally located square was purchased by the community of Germantown in about 1704, and a market house was built here in 1745 along the lines of New Market at 2nd and Pine Streets. It was here that the Paxton Boys, country folk out for revenge against local Indians, met a militia hastily organized by Benjamin Franklin. Franklin's party (which even included a few rifle-toting Quakers) was able to pacify the Paxton posse before any great harm could be done, save a church weathervane riddled with pot shots.

The local Civil War Monument is shown in the foreground. Note the variety of roofing materials: standing seam terne, wood shingle, rough shake, and slate—all quite common then and now in this area.

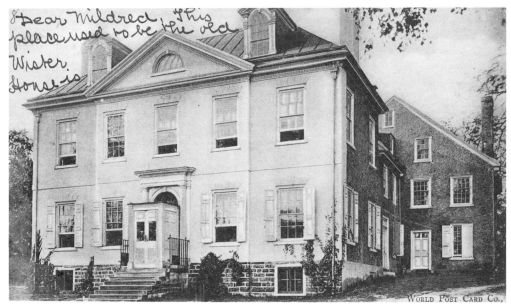

1905: Known today as Vernon Mansion, this was the home of John Wister, a botanist who purchased the 1805 home from James Mathews. The rear section visible on the right was built sometime around 1741. Wister named it after Washington's home, Mount Vernon, and planted the property with a variety of shrubs and trees, some of which still survive in the park that now surrounds the mansion. Vernon was acquired by the city in 1892 and served as a branch of the Free Library from 1889 to 1907. At this time, it is not open to the public.

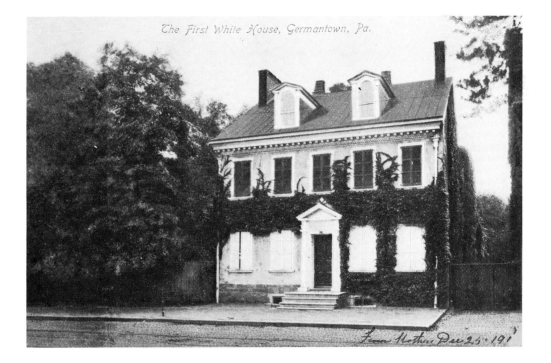

The Morris House, 5442 Germantown Avenue, 1907: Now known as the Deshler-Morris House, this fine example of German domestic architecture was built as a summer home in 1772 for David Deshler, a local importer. It lies opposite Germantown's Market Square. It has been called the first "White House" because President Washington stayed here during the 1793 yellow fever epidemic and returned the next summer for a six-week stay. Ironically, this was also headquarters for General Sir William Howe, his opposite during the Revolutionary War.

The Morris family owned the home from 1834 to 1948 when it was given to the Federal government. It is now restored and a part of Independence National Historical Park.

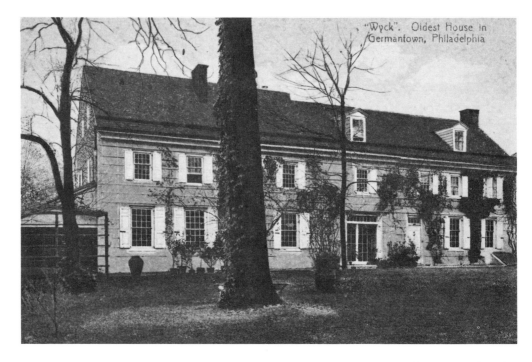

Its first sections built about 1690, "Wyck" is thought to be the oldest house in Germantown. A number of alterations have been made over the years, and the present structure is actually two houses joined over a former wagon path. It served as a hospital for British wounded in 1777. This was the residence of the Haines family from the time when they cleared the land until 1973 when the home was presented to the Germantown Historical Society. The house and many of its original furnishings are on display to the public along with the original smoke, ice, and carriage houses.

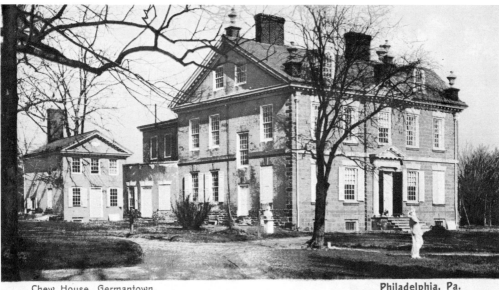

Chew House, Germantown. Philadelphia, Pa.

6401 Germantown Avenue: During the Battle of Germantown in 1777, it was discovered that five companies of British soldiers had barricaded themselves in the Chew House. The sturdy stone mansion proved an excellent fortress, and Washington's men were forced back. The front door was blown out by American cannon, but an attempt to rush and torch the house was unsuccessful. A man with a flag of truce and terms of surrender was shot dead on the front lawn. Further confusion and bad luck gave the British the upper hand and the victory. After the smoke cleared, Benjamin Chew returned to this, the country home he called "Cliveden," and repaired the damage, but battle scars are still visible to this day.

Built in 1763, this home was in the Chew family until 1972 when it was acquired by the National Trust for Historic Preservation. It is now a museum and an important repository of 18th century furniture.

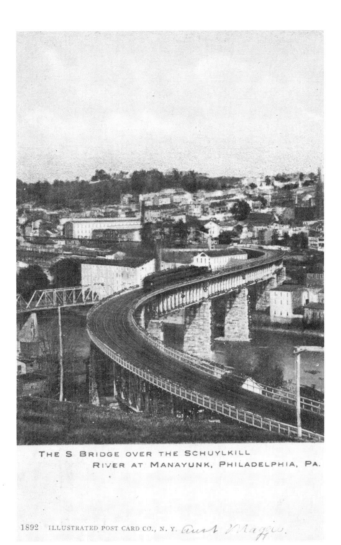

THE S BRIDGE OVER THE SCHUYLKILL
RIVER AT MANAYUNK, PHILADELPHIA, PA.

1892 ILLUSTRATED POST CARD CO., N. Y.

1905: Named for the original Indian word for the Schuylkill River, hilly Manayunk was little more than a toll house in 1820; but within five years, it became a burgeoning mill town. The Schuylkill Navigation Company's canal system and millrace brought water power and access to the area, making it one of the premier textile producers in the country. By 1828, there were 104 mills here, employing almost 10,000 workers who put in six-day weeks, 14 hours a day for $4.33 per week. The Fourth of July was their only holiday. A few of the old buildings survive, although Manayunk is no longer a textile capital. This railroad bridge across the Schuylkill still stands just east of Greene Lane.

Miscellany

"Seeing Philadelphia"

Dear Old Philadelphia

Copyrighted by GERTRUDE MOSSELL

(Published by "Seeing Philadelphia" Automobiles,
Keith Theatre Building)

The streets may be the narrowest
 In **dear Old Philadelphia,**
But still your course is straightest
 In **dear Old Philadelphia.**
You have to try to lose your way,
Is what its people always say
If you should ever go astray
 In **dear Old Philadelphia.**

No other city boasts a bell
 Like ours in **Philadelphia.**
No one has such a tale to tell
 As this one in **Philadelphia.**
Though cracked and old, well! well!
It "traveled some" this ancient bell,
And never has its value fell
 Since owned by **Philadelphia.**

When visitors come here they say
 'Tis **dear Old Philadelphia.**
To Independence Hall they wend their way
 While "**Seeing Philadelphia.**"
The State House first attracts their gaze
With all its independent ways,
Next City Hall when its ablaze
 On Holidays in **Philadelphia.**

George Washington's old home in Germantown,
 A part of **Philadelphia,**
With that of Betsy Ross who made the nation's flag
 Still stand in **Philadelphia.**
And U. S. Mint and Fairmount Park will stay
Still in your mind whene'r you say
They may be slow, but what a day,
The Quakers showed us in **Philadelphia.**

The first of almost everything
 Began in **Philadelphia,**
The last of everything also belongs
 To **dear Old Philadelphia.**
They leave New York, they sometimes say,
To go and rest a week or day
While wondering at the Quaker gray
 Still worn in **Philadelphia.**

But we don't care; we're satisfied
 With sleepy **Old Philadelphia.**
You know we have ancestral pride
 In **dear Old Philadelphia.**
We know this always makes you smile,
And taunt us every little while,
And yet we think we have you "skinned a mile"
 By just being born in **Philadelphia.**

The "Seeing Philadelphia" automobiles left from in front of Keith's Theatre on Chestnut Street. It is hoped that the tour was more inspiring than this poem.

114

1908: The Society of Friends (popularly known as the "Quakers") have exerted an influence on its City of Brotherly Love beyond its relatively small numbers. In fact, Philadelphia is still known as the "Quaker City."

1905: There are, by the author's count, 46 different views in this souvenir card, and the studious reader of this volume should be able to identify a good many of them. Despite the loss of many buildings over its history, it is amazing how much of Philadelphia's architectural heritage has been preserved, either by accident or on purpose.

Please visit; there is much to see.

Bibliography

Brandt, F. B. and H. V. Gummere. *Byways and Boulevards In and About Old Philadelphia*. Philadelphia: Corn Exchange National Bank, 1925.

Brenner, Roslyn F. *Philadelphia's Outdoor Art*. Philadelphia: Camino Books, 1987.

Burt, Nathaniel. *The Perennial Philadelphians*. Boston: Little, Brown and Company, 1963.

Curson, Julie P. *A Guide's Guide to Philadelphia*. Philadelphia: Curson House, 1986.

Federal Writer's Project. *WPA Guide to Philadelphia*. Philadelphia: University of Pennsylvania Press, 1988.

Finkel, Kenneth. *Nineteenth-Century Photography in Philadelphia*. New York: Dover, 1980.

Foundation for Architecture (Philadelphia). *Philadelphia Architecture*. Cambridge MA: MIT Press, 1984.

Glazer, Irvin R. *Philadelphia Theatres, A-Z*. Westport CT: Greenwood Press, 1986.

Looney, Robert F. *Old Philadelphia in Early Photographs*. New York: Dover, 1976.

Oyan, Susan. *Philadelphia Then and Now*. New York: Dover, 1988.

Stiefel, Bernard M. *The Philadelphia Trivia Quiz*. Kansas City MO: Normandy Square, 1984.

Webster, Richard J. *Philadelphia Preserved*. Philadelphia: Temple University Press, 1981.

Weigly, Russell F., editor. *Philadelphia, a 300-Year History*. New York: W. W. Norton & Company, 1982.

White, Theo B. *Philadelphia Architecture in the 19th Century*. Philadelphia: University of Pennsylvania Press, 1953.

Index

Philadelphia in Postcards
1900–1930

was composed in 9 on 10 Korinna on a
Merganthaler Linotron 202N with display
type in Korinna Kursive Bold
by Eastern Graphics;
printed by sheet-fed offset on 70-pound acid-free
Sterling Litho Satin,
and bound in 12-point coated stock
by Johnson City Publishing, Binghamton, N.Y.;
and published by The Vestal Press, Ltd.
Vestal, New York 13851-0097

Cover design by Joseph Mastrantuono

Library of Congress Cataloging-in-Publication Data

Jamison, Philip. 1952-
 Philadelphia in postcards. 1900–1930 / by Philip Jamison III.
 p. cm.
 Includes bibliographical references and index.
 ISBN 0-911572-89-9 (pbk. : acid-free paper) : $11.95
 1. Philadelphia (Pa.)—Description—Views. 2. Philadelphia (Pa.)—
History—Pictorial works. 3. Postcards—Pennsylvania—
Philadelphia. I. Title.
 F158.37.J35 1990
974.8'11042'0222—dc20 90-12843
 CIP

Printed in the United States of America

First Printing October 1990

Cover design by Joseph Mastrantuono